Hook Me a Story

The History and Method of Rug Hooking in Atlantic Canada

Deanne Fitzpatrick

NIMBUS
PUBLISHING

Nimbus Publishing Limited
PO Box 9166
Halifax, NS B3K 5M8
(902) 455-4286

Design by Graphic Detail, Charlottetown, PEI
Photography by Dale Wilson, unless otherwise credited.

Foreword, by Doris Eaton, reprinted with permission from the AGNS catalog, "One for Sorrow."

Printed and bound in China

Canadian Cataloguing in Publication Data
Fitzpatrick, Deanne.
Hook me a story
ISBN 1-55109-279-4
1. Rugs, Hooked—Atlantic Provinces. I. Title.
TT850.F58 1999 746.7'4 C99-950059-7

Nimbus Publishing acknowledges the financial support of the Canada Council and the Department of Canadian Heritage.

Acknowledgements

No one ever does anything on their own. Many people have helped me create this book. I would like to thank Doris Eaton, Dorothy Blythe, Harry Thurston, Doris Norman, The Heritage Rug Hooking Guild, The Rug Hooking Guild of Nova Scotia, Doreen Wright, Barbara Kincaid, Sylvia MacDonald, Peter Laroque, The New Brunswick Museum, Donna Fitzpatrick, Joan Beswick, Lily Deyoung, Carol Oram, Donna Farrell, Caroline Foster, Patricia Grattan, The Art Gallery of Newfoundland and Labrador, The Art Gallery of Nova Scotia, Geri Nolan Hilfiker, Virginia Stephen, Judy Deitz, The Sir Wilfred Thomason Grenfell Historical Society, Elizabeth Lefort, Les Trois Pignons, Joan Foster, Kate Westphal, Dale Wilson, Shirley Hogan, Marlene Reid, Joan Bolivar, Betty Laine, Lucien Oulette, The Canadian Museum of Civilization, Cathy Consentin, Dan Walker, Don Miller, Linda MacDonald, Marjorie Nelson, Joyce Carrigan, Joan Foster, Sylvia Fairbanks, and Marion Kennedy of Tatamagouche, N.S. who taught me how to hook. Your generosity, insights and information have been important to me and a valuable part of this project. *Thank you.*

"But she remembered Joseph. The grey in the first lap of circle next to the border was a workshirt of Joseph's. She remembered Martha feeling it for texture the first day he tried it on, the day he went back to cut the keel. It still looked almost new. Where was Joseph?"

"The next ring of flowered gingham was an apron of Martha's, Martha had sat that night with this apron to her eyes, but what night had it been?"

"She drew the last garment from the bag. It was a dress. Her fingers touched a bit of lace at the bottom of her sleeve. It must have been for a wrist no larger than mine, she thought."

Ernest Buckler, *The Mountain and the Valley*

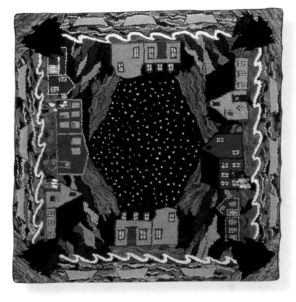

"Mummers on a Starry Night," 70 x 72 inches. A room-sized rug hooked for the floor so that it can be viewed from all sides. This rug shows "mummers" going from house to house. Mummering was done in Newfoundland at Christmas. Revellers would dress in costume and visit neigbours sharing drink and fruitcake. Designed and hooked by Deanne Fitzpatrick, collection of Don and Nancy Guest.

This book is dedicated to my mother, Anne Fitzpatrick. Having had to hook when she was a child as a chore of poverty, she quit making rugs for sixty years. She began hooking again when she was seventy years old. In the last six years, she has made ten mats. Also to my husband, Robert Mansour, who didn't blink an eye when I told him I was going to stay home and hook rugs instead of going to work.

Contents

Foreword

The growth of rug hooking in Atlantic Canada over the past ten years has been quite phenomenal. In Nova Scotia, this is probably due in large part to the organization of the Nova Scotia Rug Hooking Guild, whose purpose is to further the craft in gatherings, workshops, courses, displays, and exhibitions—whatever it takes to promote interest in rug hooking. A one-week rug hooking school was the Guild's first major project, and this has continued annually since 1980. Held in early May at the Nova Scotia Argricultural College in Truro, the school is currently at full capacity, attracting students from all over North America.

As a teacher of rug hooking for many years, I've been in a unique position to watch this artistic craft's growth, and have hopefully encouraged it and its strong local tradition. I get very excited when I see the joyful expression and original imagery emerging in lively creations on all sides. No one style in particular is representative of the Nova Scotian tradition, but certainly a standard of excellence exists in most of the work produced here today.

The first time I saw Deanne's rugs, I sat up and took notice. What I see in her work is not so much a reflection of a Nova Scotia rug hooking tradition, as it is an expression of her strong sense of her own roots. With her colourful hand-cut rags and her sense of design she brings to us a wonderful image of her native Newfoundland. She is not drawing on the influence of the geometric rugs of Lunenburg County or on the finely shaded work in yarn of the Cheticamp creations, nor indeed on the infinite variety of works in between.

There were many, many examples of these styles beautifully evident during the special events and exhibitions surrounding Nova Scotia's designated "Year of the Hooked Rug" in 1995. Hooked rugs were highlighted and featured all across the province, from Sydney to Yarmouth and also into New Brunswick and Prince Edward Island.

Deanne's rugs, however, express her connections to Newfoundland—it is this experience that she draws on when creating her art. So much of her

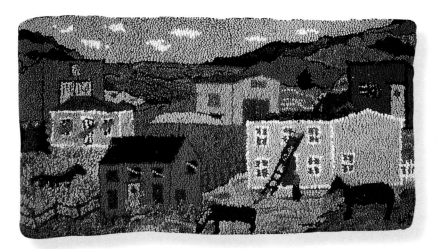

"Leave or Stay," 36 x 70 inches. In the 1950s in Newfoundland, people were forced as a community to make a decision to stay or leave their outport homes. This caused some friction among neighbors; while some people painted their houses, others boarded them up.

Photo by Geri Nolan Hilfiker

heart is in her work that it reaches out and tugs at mine. And for me, that's the essence of her hooked rugs—her unique style and personal expression.

Rug hooking is quite a simple craft, really. A hook, often home-made, held in the palm of your hand, is the only tool used. Backing material is stretched onto a frame, either free-standing on the floor or held on the lap, and strands of pre-cut material are pulled through the backing to the surface in a series of loops, which stay where they're put, and which eventually become a personal creation. Rags are usually of wool, cut into strips by hand, or by using a small machine with a handle, producing several strips at one time.

All manner of colours and textures are used—whatever comes to hand of discarded clothing—in an ultimate recycling effort to make a work of art, or at least a mat for the back door. Bits of material are spread before you or bunched up in a basket at your side, and it becomes a matter of choosing exactly what you want to put into a particular spot of the piece

Facing page: "The Wavy Runner," 13 x 55 inches. This rug takes a simple oak leaf design and repeats it. Curving the edge makes it look a lot more interesting on the floor.

you're working on, to give the effect you're looking for. From this point on—when materials and colours and textures are all before you and a line drawing is on the backing stretched in front of you—each rug hooker expresses herself in an individual way, simply by the choices she makes to execute her piece. This is when an artist can soar!

This is also the point where differences in artistic expression occur. The fine wool can be cut into narrow strips and hooked with technical finesse, carefully and patiently, one loop at a time, to create a unique, finely shaded tapestry or a precise geometric of timeless beauty.

This is when Deanne's rugs become her own personal expression, and we discover who she is and where she's coming from. *Now her art tells us her stories.*

Simply by her choice of colours and fabrics, and by her spontaneous approach, she expresses her heartfelt emotions in her depiction of things personal and revealing. I marvel at her ability to express so much with a few loops of fabric, placed just so, with the colour just right.

Somehow, as observers of a variety of hooked pieces, we can pick up on differences and react to them. Some of us do so on an intellectual level, some on a purely emotional level. To me, there is a marked difference when an artist has put herself into her work. I feel it. I react to it. I feel that Deanne has this ability and with her colour choices and loops of fabrics, she is telling me a story. I respond with a true appreciation of her message to me.

In her work, I see her passion for her land and love of her people. In her rugs she speaks to us of things she knows. We see people gathered in groups or doing their own thing. People are very important to Deanne, both in her life and in her work; people are important to the communities of Newfoundland and to the place where she grew up. These mats tell me what life must be like in Newfoundland and how it differs from my life in my own community in Nova Scotia. Houses in Deanne's rugs are large two-storey affairs, accommodating large families. We see land broken up into plots and fenced round. It isn't easy to plant gardens or

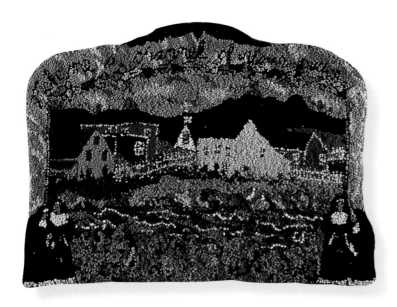

"Make me a Channel of your Peace," 42 by 36 inches, a rug completed upon hearing about the death of Mother Theresa, and in memory of the nuns who taught me while I was growing up. Collection of Donna Fitzpatrick and Jim Murdoch.

encourage lawns on "The Rock," so the plots are small and then fenced to keep the animals out, not in.

Deanne tells us of her childhood, the joys of her life back home, and sometimes of the plight of her people. She remembers family gatherings, community events, church socials, bees and tea parties, villages and homes and outports—water and land together. She remembers her grandmother's hooked pieces. That's where she's coming from.

As artists down through history have left us a legacy of their sense of place in the here and now, so Deanne is telling us the story of her life in Newfoundland and of her strong attachment to her roots.

To be true to yourself and to the art form in which you choose to work is the best we can ask of any artist.

Doris Eaton,
Italy Cross, NS.

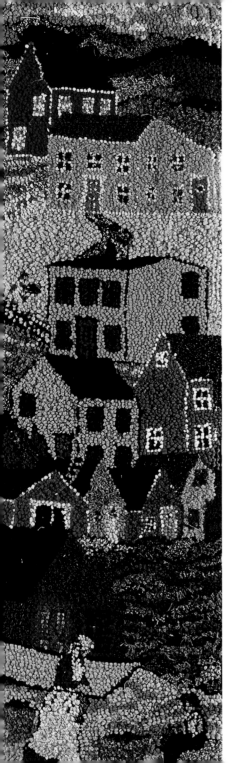

Introduction

I so wish that I could say that I learned to hook at my mother's knee, or that my grandmothers had lovingly passed on their hook for me to learn with, but I did not receive such gifts. When I was growing up in the 1970s in rural Newfoundland, it was "in with the new and out with the old." My parents had been gone from their outport homes for over 25 years and both my grandmothers had passed away before I was born. Only scant traces of this rich tradition of mat hooking remained: an old hook in someone's shed, or an old mat by the back door. Hooking was thought to be old fashioned. Wall-to-wall carpeting, and central heating were what mattered then. They were easier to come by, and did a lot more to quell the strong winds and damp fog that generated off Placentia Bay.

Though I do not remember hooking in my home, neither do I remember a time when I was not familiar with hooked mats. I was very little when my father first told me about the rugs his mother used to make out of their old clothes. In my late teens I remember looking at old mats and thinking about the process of making them, marvelling that a woman had pulled up every loop by hand. I could not help but think how many hours a woman had put into a mat, and the activity happening around her as she hooked.

Mats have always been a way of telling stories. They were records of family histories told in the remnants of clothing that family and friends had worn. Stories were also told in the design of a mat, especially those that women designed themselves before the advent of stamped patterns. Homes, pets, boats were drawn on the burlap as symbols of the makers' life. The old mats provide a visual and textual history of life in Atlantic Canada.

Hooking stories is what makes me passionate about making rugs. Sometimes I use hooking to recount an experience or a memory; sometimes to create a fable, a romantic story, or a dreamscape of a village that may have been. A hooker can set out to tell one story, while someone who looks at the completed mat can see quite another. Either way, a mat is a story in itself without the maker ever having to say a word.

It was not until I was twenty-five that I finally learned to hook. I had settled down in an old farmhouse outside Amherst, Nova Scotia and I wanted to cover the old floor boards with hooked mats. Those to be had at auctions and antique stores were either too expensive or too worn out for my tastes. I decided that I would try to make some myself and registered, with three of my sisters, for a beginner lesson from Marion Kennedy, in Tatamagouche, Nova Scotia. As soon as I began hooking I knew that it was for me. As I pulled up the first few loops I recognized that this was something I could complete. I could see my progress as the loops of cloth quickly covered the burlap. I stayed up late hooking that first night and finished my first rug within a week, working on it every night. Since then I do some hooking nearly every day, sometimes for ten minutes, sometimes for hours.

My first mat was a simply stamped pattern with scrolls and a few flowers. All the wool I needed came with it as a kit. Soon I began collecting wool clothing to tear up as rags for some simple designs that I was drawing on burlap bags which had come from a middle eastern food store in Halifax. As time passed I began using better quality backings and my designs became more expressive.

One of the beauties of making mats is that it can be a simple past-time that approximates the colouring you may have done as a child. You can choose from a wide variety of stamped patterns, and by outling and filling in you can make warm and delightful mats. Or you can design your own patterns. Whether your designs are complicated or simple primitives, the thrumming motion of pushing the hook through burlap and pulling up loops of cloth is a soothing and relaxing activity. It is a chance to escape into a world of colour, texture and design, to carry on a tradition that has spanned generations, and continues to thrive in Atlantic Canada today.

Deanne Fitzpatrick,
Amherst, NS.

Facing page: "Fishwife &
Son," 16 x 60 inches.
A mother teaches her son to
clean fish on the waterfront.
I remember the excitement of
cleaning the fish in our
kitchen; we'd throw the guts
on our neighbors' garden.
Blue flies would buzz around
crazily. Collection of Heather
and Jens Jensen.

An historical perspective

Early Settlers Covering Cold Floors

Most authorities suggest that mat hooking first appeared in Atlantic Canada between 150 and 175 years ago. Some estimate that it began as early as 1800. All agree that it bloomed in the 1850s. Its origins are a bit muddied, and no one has actually pinned down an exact place or date of origin. This is of course what makes it a folk art, one that likely developed through a rural tradition, such as a mother teaching her daughter to make a mat.

Scott Robson, curator of the history collection at the Nova Scotia Museum in Halifax, Nova Scotia has said that the earliest examples of hooked rugs from Nova Scotia would have been on a linen backing, while burlap sacking would not have become widely available until the 1850s when English-made machines were used to produce burlap cheaply in India. It is sometimes thought that primitive rug hooking originated on the Eastern seaboard of North America, while others feel that the strong traditions of rug making and embroidery from Asia, India, Europe, Scandinavia, and Britain were the forebears of this craft. When I first began hooking rugs I found a book written by William Winthrop Kent in the 1930s called *The Hooked Rug*. In this book, which is still a common reference for researchers and writers today, he suggests that the rugs were of British origin. In his research he also found that techniques very similar to rug hooking could be traced back to ancient Egypt and Scandinavia. In recent times, many people have disputed his theories, suggesting that rug hooking is one of the few folk arts native to North America. In their book, *American Hooked and Sewn Rugs: Folk Art Underfoot*, Joel and Kate Kopp refer to a body of textile and rug authorities who have argued that rug hooking began in North America. In the 1940s, Marius Barbeau, an esteemed researcher and collector of hooked mats from The Canadian Museum of Civilization, believed that mat hooking began in North America. He gathered many of the rugs in the museum's

collection, including the oldest one by Mrs. F.X. Paradis, which is estimated to be between 125 and 150 years old. William Kents' suggestion that the rugs are of British origins is mainly disputed by the fact that there are no early examples of this type of rug hooking in British museums or private collections. However, there are plenty of examples of early "Proddy" or "Proggy" mats that were made in in Britain. These clipped mats differ from hooked rugs, in that individual peices of wool cloth are pushed through the back of the sacking to the right side of the rug to create the effect of a thickly piled shag carpet. This type of hooking did travel to North America and is still popular today on Tancook Island off the south shore of Nova Scotia. The technique of primitive rug hooking may have developed in North America, as many researchers have suggested, but it undoubtedly was derived and perhaps influenced by centuries worth of handworks that preceeded it. Bed rugs, yarn sewn rugs, shirred rugs, proddy rugs, and decorative tambour embroidery, all predated the hooked mat and most certainly contributed to the development of the techniques used for primitive hooking.

The discussion about whether the first rug was hooked in Canada or the United States also remains unresolved. Rug hooking first began in Maine, New Hampshire, the Atlantic provinces and Quebec, and it quickly spread throughout the Atlantic Seaboard. There is no founder or developer of the technique that we can refer to, no definitive place of origin, and no precise date to its beginnings. It seems that rug hooking began in all four Atlantic Canadian provinces and Quebec around the same time that it developed in Maine and New Hampshire. It was done with rags on a backing of linen or burlap feed sacks. There were not great differences in the way that rug hooking developed in each province. The variations that took place throughout Atlantic Canada were often related to the area where you lived within the province rather than the province itself. Many of the changes that developed over the years were a result of the influence of people "from away." For example, in northern

Facing page: "Aunt Mary," 14 x 49 inches. This is how I remember my Aunt Mary Turner, who would stand at the door of her house in St. John's, waiting to greet you and give you something. Collection of the artist.

Newfoundland Sir Wilfred Grenfell developed the Grenfell Style, and Lillian Burke, a New York artist, worked with the Cheticamp women to develop the Cheticamp style.

The making of domestic textiles such as mats was mostly carried out by women. Although some men, often as boys at their mother's knee, learned to hook. Men, and children of both sexes, often cut the rags for women while they hooked the mats. Mat making was also known as a past-time for men while they were out at sea for long periods of time. But, primarily it was done by women and girls in the home, or at occasional hooking bees where women gathered to work on the mat together.

Mat making was not just a pleasant past-time for idle hands; it had an important role in the early settlers' household. Hooking recycled fabrics and bits of clothing that no longer served a purpose was a way to create floor coverings for cold damp floors. My own mother who grew up in outport Newfoundland in the 1920s refers to mat making as a chore of poverty. It was something she had to do after school to help her mother provide for the family's comfort. Many women did not see it as a task of drudgery. For them it was a way of decorating without spending money, for they had little or nothing to spend. According to her children, my grandmother Emma Wakeham Fitzpatrick was well known in her community of Paradise, Newfoundland for her mat designs. One design featured a house with a path leading up to it and a small garden. She hooked her designs sitting by the wood stove in the kitchen. She would often create patterns for her friends and neighbours by using a piece of charred wood to draw pictures of dories or schooners upon a piece of burlap.

Like her contemporaries, she mostly used wool cloth, as this was a popular fabric for clothing of the day. Still, whatever she had on hand would be used; nothing was ever thrown away. When she ran out of old clothes to cut into strips she would dismantle a piece of burlap strand by strand. Then, she would dye the strands, gather several of them together and hook the "cloth" into another piece of burlap. Anyone who loves to

hook will understand the compulsion to create that drove her to take on such an arduous task. She would have twenty or thirty rugs in the house at any given time. Some of the grandest ones were rolled up under the bed only to be taken out when a special visitor, such as the priest, made his parish rounds. Often the floral rugs were put in the parlour while the hit and miss rugs—made by striping bits of leftover fabric—were placed on the floor by the back door.

According to Lucien Oulette, curator of "Hooked on Rugs," a 1998 show of Canadian Hooked Mats at The Canadian Museum of Civilization in Hull, Quebec, the design of hooked mats in Canada has progressively changed over the years. "Initially there were more floral and geometric designs, then images of animals began to appear; by the turn of the century landscapes became popular, and eventually more scenes of life." Of course it was not an exact progression. His observation was based on the study of the museum's collection of more than 400 hooked mats from all over Canada.

Initially, mat designs were drawn freehand on burlap, but commercial designs became available by the latter part of the 1800s. While some women continued to design their own mats on feed bags using images from bits of china, pictures, other mats, or their surroundings for inspiration, many of those who could afford to began to use stamped patterns in the latter 19th century. Various businesses cropped up selling stamped patterns to women. The first stamped patterns were created using stencils by Edward Sands Frost of Biddeford, Maine. While watching his wife making a rug, he became interested and started hooking himself. After they finished the rug, he decided that he could create a better design himself. Within three days of creating his first drawing, he got orders for twenty or more patterns. In order to meet the demand for his patterns he created a set of stencils to cut down on his labour. His business became very successful, and the idea of the stamped pattern quickly caught on in Atlantic Canada.

Emma Fitzpatrick. None of my grandmother's mats are around today.

Scott Robson, in an article on the history of textiles in Nova Scotia, identifies three main suppliers of stamped patterns. Within a few years of the emergence of patterns in New England, a partnership was formed in 1879 in Yarmouth by Perry and Grantham to create mat bottoms. Sadly, none of these are in existence today. Soon after, in 1892, John E. Garrett established his mat printing business in New Glasgow, Nova Scotia. In addition to running a mail order operation, these patterns were sold through Eaton's, The Hudson's Bay Company, and by various other large retailers and agents in Canada, the United States, and Britain. A third mail order company, Wells and Richardson of Montreal, sold stamped patterns and Diamond Dyes. These dyes were popular for dying both rags and yarn, and were used extensively by the women who could afford them.

Although the emergence of stamped patterns helped to reinforce an already strong tradition of rug hooking in Atlantic Canada, it did have the effect of quelling the creativity involved in designing mats. Once the stamped patterns became available, many people became critical of, or embarrassed by, their own creations. Instead of seeing the eloquence of their simplicity, they could only see the crudeness of their work. Creativity, however, continued to thrive regarding colour and texture. The same stamped pattern completed with a different colour scheme were often unrecognizable from each other. The advent and easy availability of commercial dyes helped women become more creative with their use of colour, when hooking stamped patterns.

The mats most prized today by museums and collectors are those like my grandmothers would have made, hand-drawn and of their own design. Unfortunately, these are few and far between. None of my grandmothers mats are around today. Mats had a function; they laid upon the floor and were walked upon daily. As the best mats in the parlour became dull or grayed, they were brought into the kitchen where the wear was harder. Their last stop was often the back porch or the back door. There, their already fragile burlap backings were drenched with the harsh saltwater of

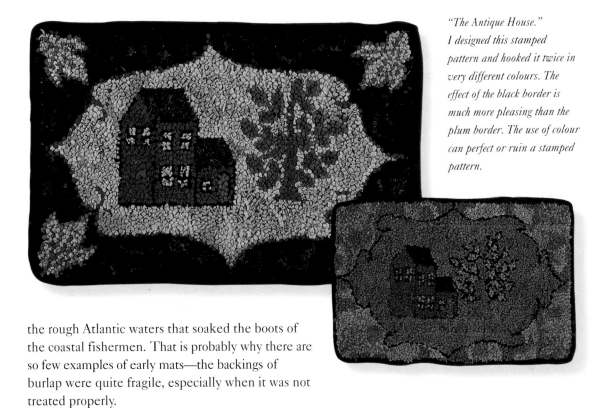

"The Antique House."
I designed this stamped
pattern and hooked it twice in
very different colours. The
effect of the black border is
much more pleasing than the
plum border. The use of colour
can perfect or ruin a stamped
pattern.

the rough Atlantic waters that soaked the boots of
the coastal fishermen. That is probably why there are
so few examples of early mats—the backings of
burlap were quite fragile, especially when it was not
treated properly.

My Aunt Mary tells me that one of her least favourite chores was
cleaning the mats. To do this, she would take a bundle of mats down to
the little wharf near her father's stage and dip them in the salty waters of
Placentia Bay. From there she would shake them, and try to wring them
out, then lay them flat on the wharf to dry. No doubt she wasn't the only
young girl who dreaded this chore. It is sad to imagine how many creative
designs, how many wonderful mats, have virtually dissolved along our
shores. The loss of these mats also helps to explain why historians have
had so much difficulty originating and dating the beginnings of mat

making in Atlantic Canada. The original mats have most likely disappeared. Another reason for the loss of many old mats is that they literally went out of fashion and were no longer valued. As they became available, and as people could afford them, factory-made carpets and linoleum began to warm the floors of rural people. The rugs were seen by many as a sign of the hard times and the poverty they had experienced. People had little desire to pass on the dull and grayed mats that laid about the floors of their family home. They were often left behind when a home was sold or abandoned. A good many of them were tossed off as rubbish.

During the times when rug hooking was flourishing in Atlantic Canada, many mats were sold to upper Canada and the United States. Nearly every youngster had a story to tell about their mother selling the hooked mats she made over the winter to the peddlers who arrived at the door in the spring—a further reason why many of our ancestors mats are no longer to be found. Sometimes they were sold for as little as twenty-five cents or a dollar. Often, no money even changed hands and the mats were traded for a square of linoleum. Today this story is often told with regret, as it represents a loss of culture, and a family's heirlooms. Still, one can imagine how it must have felt for a woman at home, with no money of her own, to be able to sell the mats that she had made over the winter.

The trend to selling hooked rugs continued with the emergence of strong cottage industries. Hooked rugs made with wool yarn in Cheticamp, Cape Breton, as well as through the Grenfell Mission in St. Anthony, Newfoundland were sold in the New England market. Commercial enterprises also developed in New Brunswick. Through the depression, people continued to make rugs and the craft reached the heights of its popularity prior to World War II. After the war, tastes seemed to change: linoleum, tiles, and wall-to-wall carpet gradually erased the need to hook rugs. Women became busier with work outside the home and had less time for such hobbies. Rug hooking became old fashioned; a thing of the past.

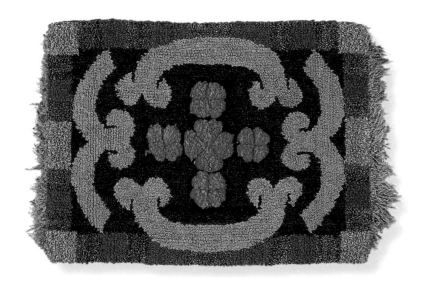

"Riz Roses," 15 x 21 inches. This mat, from northern New Brunswick, is hooked with burlap strands on burlap. When women ran low on fabric, they would dismantle burlap bags to use as hooking material. The flowers in the centre were hooked higher than the background; this was commonly referred to as "riz roses," or "hoven up." Today, this is referred to as sculpturing. Collection of Doris Norman.

The re-emergence of rug hooking in Atlantic Canada today is strongly due to the perseverance of women such as Edna Withrow and Doris Eaton. Withrow moved to Wolfville, Nova Scotia from Ottawa and had a strong influence on rug hooking in the province. It was through the Handcraft Centre of the Nova Scotia Government that she began teaching people such as Doris Eaton and Sylvia MacDonald to hook. They went on to form The Rug Hooking Guild of Nova Scotia in 1979, which continues to thrive today. In 1995, the Rug Hooking Guild of Newfoundland and Labrador was founded. Today rug hooking continues to flourish with several supply shops across Atlantic Canada and a thriving presence on the internet. Artists such as Nancy Edell, Rose Adams, Doris Eaton, and the author have had shows of hooked rugs in regional and university art galleries, bringing attention to the fact that rug hooking is once again an emerging art form. What we once thought to be a thing of the past, now has a promising future.

Sylvia MacDonald and Edna Withrow were both influential in revitalizing rug hooking in Atlantic Canada.

Mat making in Atlantic Canada

Newfoundland and Labrador

Mat making, as it is referred to in Newfoundland, has existed there since the 1850s. Surrounded on all sides by the stormy Atlantic, and a harsh but beautiful landscape, women made mats in their outport homes for decoration and utility. The mats of outport Newfoundland usually included repeated patterns—roses, and striped blocks—commonly called "hit and miss." Most women avoided the more realistic patterns that the Maritime women were hooking. The earlier Newfoundland mats feature a love of colour, brightly painted houses, and a strong tradition of geometric designs. A wide variety of fabrics were used in Newfoundland hooked mats—whatever rags they had on hand would be hooked into a rug.

By the time I was growing up in the 1970s in Placentia Bay, mat hooking was outdated in Newfoundland. There was the occasional reminder, like an old hook in someone's shed, or the grayed mat in my grandfather's house. These were subtle reminders that hooking was a hobby of the past. One childhood friend, whose mother still hooked in the 1970s, remembers being embarrassed that her mother still made mats to cover their floors. To her, and to all of us, rug hooking was old fashioned and of no value. In Newfoundland, at that time, all things modern were the hope for the future. More recently, a new appreciation for hooked mats has arisen in Newfoundland, as it has in other places. Grenfell Industries, and several other producers, including The Placentia West Mat Makers, and Drogheda Mats, continue to produce and sell mats in Newfoundland.

The Newfoundland and Labrador Rug Hooking Guild is also becoming an active participant in reviving this traditional art form. Since their

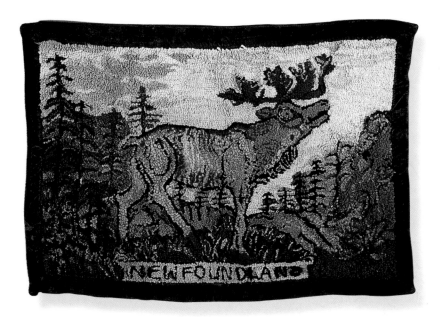

*"Newfoundland Caribou,"
30 x 43 inches. This mat was
found in the home of Fred and
Isabel Emmerson, of St.
John's, Newfoundland, and is
now owned by their grandson
David Holt. Notice the depth
and artistic execution of the
wools used in the background.
The pitcher plant in the corner
is Newfoundland's floral
emblem, and the caribou is the
provincial animal.*

formation in 1995, they have held three workshops, and through their
network of members have taught over five hundred people to hook rugs.
They have also been active in carrying out a heritage registry of the old
hooked mats that still exist in the province today. This registry has
travelled to various communities where photographs were taken of older
mats that existed in homes and museums. Where possible, a record of the
name of the maker, the approximate date and place of origin was also
noted. Similar registries have been carried out in other provinces.

The Grenfell mats

Grenfell Industries was set up by Sir Wilfred Grenfell in the mid-1890s
to finance his medical mission to Newfoundland and Labrador. Jessie
Luther, the first craft teacher hired by the company, recognized the skill
of the local people for making mats. She began introducing new designs

*Facing page: "Autumn in
Southhampton," 14 x 80
inches. This rug is one of my
"fall rugs." Each year after a
drive to see the colours I come
home and make an autumn
scene using wools that remind
me of the foliage. Collection of
Ellen Beswick.*

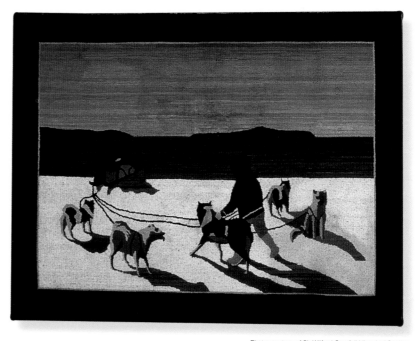

Sir Wilfred Grenfell founded mat making as a cottage industry in Newfoundland.

A Grenfell mat. Lapp dogs, and men in parkas, hooked horizontally in straight lines, is typical of the Grenfell mats.

and colours which she felt would better appeal to the New England market. The pictorial designs were based on local scenes and often featured lapp dogs, fish, animals, and scenes on the ice. The patterns, some designed by Dr. Grenfell himself, were at first hooked with rags but as this material became scarce, a campaign was launched to collect silk stockings. Dr. Grenfell's slogan, "When your stocking begins to run, let it run to Labrador," was responsible for bringing donations of silk stockings to the company from many affluent women throughout the United States. The stockings were washed, dyed, and torn into strips before they were hooked into a mat. One of the common features of a Grenfell mat is that the direction of the hooking is straight across the mat. The mats

were finely hooked with up to 200 loops per inch. By the 1940s, the mats were designed more for appearance than for utility.

Rather than use their own ideas for design, women worked in their own home to complete the Grenfell patterns. Dyed rags and stamped brin (a common Newfoundland term for burlap) were distributed from the central office of Grenfell Industries in St. Anthony, on the Northern Peninsula of Newfoundland. When quality standards were met, the mats were purchased from the local women and sold in the New England market. This tradition continues in St. Anthony, on the tip of the Northern Peninsula of Newfoundland today. The Grenfell Historical Society is an active part of community life. Rugs continue to be hooked by local people in their homes. Yarn is now used instead of rags and silk stockings, and between 150 and 200 rugs continue to be sold each year.

Rug Hooking in Nova Scotia

Rug hooking has strong roots and traditions in Nova Scotia as it does throughout Atlantic Canada, in parts of Quebec, and on the Eastern Seaboard of the United States. There seem to have been several strong influences that developed in Nova Scotia and have had an impact throughout the four provinces.

The Garretts of New Glasgow

In 1892, John E. Garrett started a business that was to have a great influence on mat making in Eastern Canada—he began manufacturing rug patterns on burlap. The business blossomed from a first season's sale of 150 dozen patterns to a business that had a mailing list of 20,000 customers and was importing 150,000 yards of burlap from Scotland each year. The company also set up a small branch in Boston which did very well. They distributed their patterns through Eaton's, Simpson's, Hudson's Bay and Woolworth's. Orders were sent all over Canada and the

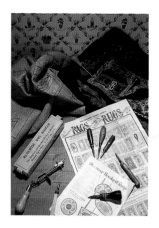

Above: Typical examples of Garrett's catalog and a Bluenose Hooker.

Right: "The Bluenose," 28 x 43 inches. This rug was hooked by Doris Norman on one of the old Garretts' patterns. The Bluenose pattern was one of the more famous of Garretts' patterns.

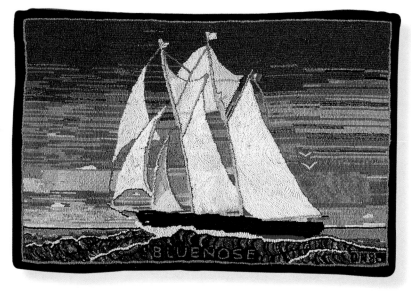

United States, and as far away as England, New Zealand, and Australia. The last catalog found in existence is dated 1974.

Garrett invented "the Bluenose Hooker" which was about five times faster than the ordinary hook and was perfect for hooking with yarn. It was manufactured in both New Glasgow and Boston. He then began promoting hooking rugs with yarn instead of rags. This lead to the commercial production of hooked mats. The mats were used primarily as a way of promoting and selling the "Bluenose Patterns" that he was so famous for. Some, however, were sold to American tourists who were beginning to visit Nova Scotia at an increasing rate.

The Bluenose Patterns consisted of over 400 designs. Some characteristic traits were large Victorian scrolls, intertwined leaves, twigs and roses. In the 1920s, Frank Garrett, who was trained as a commercial artist, joined the company. He had a strong influence on the designs of patterns,

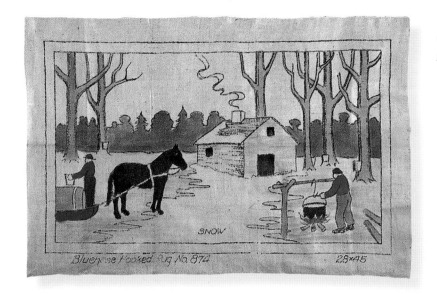

"Sugaring Off," 28 x 45 inches. A Bluenose stamped pattern from Garretts'.

and began following the trends of the time, such as the popular Art Deco themes. Two of the most popular Garrett patterns were "The Bluenose," a picture of Nova Scotia's most famed ship, and "Sugaring Off," a scene of tapping for maple syrup.

The business closed down during World War II, as it became difficult to import burlap from Scotland, and most labour was going to the war effort. After the war, the company overbought a poor quality burlap. They were further hampered when a fire in the mid-1970s destroyed one end of their building and caused a lot of water damage to burlap that they had borrowed money to buy. This, along with changing fashions, forced the business to close.

In the summer of 1998, Linda MacDonald, a rug hooking supplier, bought what was left of the Garrett's rug hooking business from an antique dealer in New Glasgow, Nova Scotia. Over a period of several

months she gathered all the old patterns, templates and stencils from the basement of the old Garrett factory by the bridge in New Glasgow. She plans to catalogue, reproduce, and once again sell the ever popular Bluenose patterns that have had such an influence on mat hooking in Atlantic Canada over the past 100 years.

The Cheticamp rugs, and Elizabeth Lefort

No trip through the Cabot Trail of Cape Breton is complete without a stop at Cheticamp. And anyone who browses the various boutiques in the village can see what an enormous effect rug hooking has had on this small fishing village. When the women of Cheticamp first began hooking, they, like their contemporaries throughout the region, used whatever fabrics were available to hook onto jute bags. Their designs and colour choices were a combination of the available materials and the designs that had been handed down from one generation to another. But the arrival in 1924 of Lillian Burke, a friend of the Alexander Graham Bell family who had a summer home in Baddeck, changed the traditional approach to hooking in Cheticamp. When Lillian Burke, an artist from New York, arrived in Cape Breton, she began buying rugs from women in Baddeck to re-sell. But at the end of the first summer she had sold only $1,200 worth. She believed that the lack of sales was due to what she felt to be unattractive colour schemes and poor workmanship. When she returned to Cape Breton in 1927, she went to Cheticamp and through Mrs. Mary Jane Doucet, a local restaurant owner who spoke English, she began working with the Cheticamp women who were receptive to making rugs to her own specification. Lillian taught them how to mix dyes to get certain colours, and she designed the patterns for them to hook. Eventually she opened a studio and gallery in New York where she sold their work. An agent who worked for Lillian in Cheticamp, gave the women money to buy the yarn and dyes they needed to make the mats. The women were paid by the square foot for the completed mat. Lillian was a

demanding task master, and she had to be completely pleased with the rugs before she would buy them. There are many stories of women being asked to take out a colour, or rehook an area to please Miss Burke. Many women were intimidated by her, while others though influenced by her, did not always follow her directions. Nevertheless, Lillian Burke's teaching and promotion have been the major influences on rug hooking as it exists in Cheticamp today.

During the depression, men and women, young and old, became active in the Cheticamp rug making industry. When people began to realize that Lillian was paying a low price for their work and selling at a much higher one, resentment grew. Miss Burke refused to pay a higher price for their rugs, so some of her workers began working with another agent, Mrs. Willie Aucoin. Others remained loyal to Lillian until her death in 1952.

Many boutiques selling the Cheticamp mats sprang up and still exist in Cheticamp today. In 1964 a group formed the "Cooperative Artisanale" which continues to be visited by tens of thousands of tourists each summer. Rug hooking in Cheticamp is now a multi-million dollar industry, which albeit emerged from humble beginnings.

One of the most famous Cheticamp rug makers is Elizabeth Lefort-Hansford. After learning to hook from her mother, she began by hooking stamped patterns, but eventually began creating her own designs. With the support and direction of Kenneth Hansford, a Toronto businessman whom she would later marry, Elizabeth began producing portraits of famous people. After completing a portrait mat of Dwight Eisenhower, Hansford arranged to have himself and Elizabeth invited to the White House so that it could be presented to him. Her portrait of Queen Elizabeth was presented to Her Majesty during her 1959 visit to Sydney and continues to hang in Buckingham Palace. Prince Charles, Lord Beaverbrook, Jacqueline Kennedy, and many other famous faces have been reproduced in wool by Elizabeth Lefort. As her work became more widely known, Elizabeth continued to create hooked tapestries. The

Elizabeth Lefort, internationally known for her portrait mats.

Photo courtesy of Les Trois Pignons

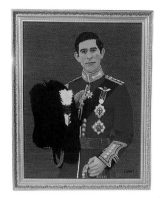

Elizabeth Lefort's "Prince of Wales."

presidents of the United States, the first seven American astronauts, the Acadian expulsion of 1755, and the Canadian Centennial were among the subjects she chose. Her most favourite work is her representation of The Last Supper. Modeled on the famous Leonardo Da Vinci painting, this tapestry measures 8 feet by 4 feet, and contains 154 shades of wool.

Most of the wool Elizabeth used was from Cape Breton sheep, which she dyed to the specific shades that she needed for her work. She also drew her own designs on the backing, using exact measurements, and enlarging to scale. Working in her studio, she attracted up to 150 tour buses each summer, and thousands of cars.

What is often said about Elizabeth Lefort is that through all her many experiences of meeting famous people, attending grand receptions, receiving an honourary doctorate degree from the Université of Moncton, and being honoured and celebrated, she has remained humble, warm, and unpretentious. She is admired by people all over the world, but most importantly she is loved and respected by those of the Cheticamp region, who named an art gallery after her at Les Trois Pignons, their cultural centre, in 1983. There some of her most beautiful works continue to be on display.

Doris Eaton and the Rug Hooking Guild of Nova Scotia

Shortly after the closing of Garretts', a woman on the South Shore of Nova Scotia began making waves that were to have a rippling effect on reviving the craft of rug hooking in Nova Scotia as well as throughout Atlantic Canada. On April 2, 1979, Doris Eaton chaired a meeting of fourteen women from the Annapolis Valley and the South Shore of Nova Scotia who were interested in rug hooking. They decided to form a provincial guild, made up of regional groups, to teach rug hooking, and to gather and distribute information on rug hooking education and exhibitions.

The need for a guild was evident because of renewed interest in the craft. Edna Withrow of Wolfville had been teaching the craft in the Valley

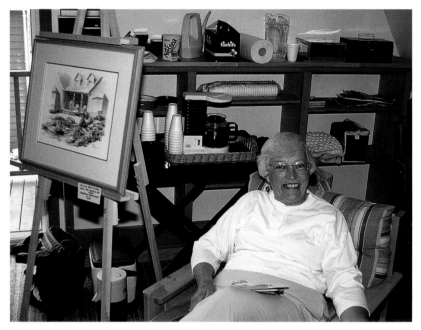

Doris Eaton grew up watching her grandmother hook rugs.

Photo courtesy of Doris Eaton

for a number of years, while Doris Eaton and Sylvia MacDonald had recently begun to teach throughout the province. By the late 1970s, Doris Eaton had about 150 students. In October 1977, Joan Moshimer, a well-known rug hooking teacher from Maine, had been invited to teach a rug hooking workshop at New Ross, in central Nova Scotia. The organizers had to turn people away as they could only accommodate 125 students. In 1980, the guild began hosting a yearly school, first at the Université de Ste. Anne in Church Point, and later at the Nova Scotia Agricultural College in Truro. The school has been a great success, annually teaching many people to hook rugs. The guild also has an active teachers' branch which hosts workshops in various regions of the Maritimes each fall. Its membership is made up of rug hookers from many Canadian provinces

and various parts of the United States. It is certainly the main organization promoting rug hooking education and activities in Atlantic Canada today. As a charter member of the guild, and tireless promoter of rug hooking in Atlantic Canada, Doris Eaton deserves special attention. Doris grew up watching her grandmother hook rugs. After attending the Massachusetts College of Art, Doris married a Canadian, Ron Eaton, and settled in Lower Canard in 1950. While looking after her five children, Doris learned to hook from Edna Withrow, and various other teachers. She has passed this knowledge on to an estimated 300 students who have learned directly from her, and to countless more who have been influenced by her work. Doris's work is unique in that it combines the technical prowess that is so emphasized by the Rug Hooking Guild of Nova Scotia, and unbounded creativity. Her work is not only strong and colourful, it is rich in meaning and content, opening a new world to those who see it.

New Brunswick

Mat hooking in New Brunswick evolved in ways that were quite similar to the other provinces. Doris Norman, past president of the Heritage Rug Hooking Guild—one of the most active guilds of rug hookers in the province today—notes that, just as is other provinces, there were areas in New Brunswick where conventions of rug hooking applied: "In parts of central New Brunswick, a mixture of cotton and wool was used. In other cases, nothing but Stanfield's underwear was used. In Victoria County, they would bind their rugs with nothing but velvet." These were not strict rules but were noticeable trademarks of a comunity or area of the province.

Doris also recalls, with delight, two corn husk mats belonging to the New Brunswick Museum, which she came across several years ago. Corn husks were dyed and cut, and then hooked on a burlap backing. The

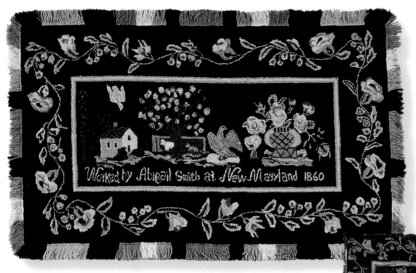

Photo courtesy of New Brunswick Museum

The Abigail Smith rug is the earliest signed and dated hooked mat in the public collection in Canada. It was hooked by Abigail Smith, of New Maryland, N.B. in 1860. It is wool yarn on burlap, 29 x 51 inches.

green, red and natural toned mat was hooked in a floral pattern and confirms that just about everything was used to hook mats.

This is certainly evidence of hooking's early beginnings in the province. The Abigail Smith rug is the oldest signed and dated hooked mat in existence in Canada. The rug, created by Abigail Smith of New Maryland, outside of Fredericton, New Brunswick, was made in 1860. In 1995, when the rug was hung as part of their show at The National Exhibition Centre in Fredericton, the Heritage Rug Hooking Guild accepted a challenge to reproduce it. Twelve members, including Doris Norman, spent over 350 hours recreating the design. Six-ply yarn was overdyed with onion skin and commercial dyes, to get as close a match to the original as possible, and hand hooked onto a linen backing. It was then donated to the museum who now uses it in its outreach program to promote New

Reproduction created by the Heritage Rug Hooking Guild of Fredericton, N.B.

Brunswick hookers. As the original rug is in very delicate condition and is not often displayed, the reproduction is a valuable tool to educate people about the oldest signed and dated rug in Canada.

The presence of an eagle on the Abigail Smith rug supports the view that rug hookers in Maine and New Brunswick were influenced by each other. Although there is no direct evidence, it was common for people along the border to travel back and forth between the two countries and to take their needlework with them. Thus they likely came in contact with each other's work.

According to Peter Laroque of the New Brunswick Museum in Saint John, there were also several commercial industries selling rugs in New Brunswick in the early 1900s. In the 1920s, Grace Helen Mowat began a cottage industry in St. Andrews selling the rugs of a group of women who worked from their home. In a similar situation, Madge Smith, a photographer with a craft and antique shop, commissioned artist Peggy Macleod to create designs. She had women hook the designs in their homes, and would then sell them in her shop. Though neither of these enterprises exist any longer, rug hooking continues to grow in New Brunswick.

Prince Edward Island

Shirley Hogan, a rug hooker from Prince Edward Island, has researched and catalogued rugs across the Island. Together with her sister-in-law she has visited the homes of numerous older hookers to view and photograph the mats that liberally decorate their floors. She discovered that, inexplicably, many Island women hooked geometrics. As well, some patterns such as the Cavendish, or The Green Gables as it was commonly referred to, seem to be unique to PEI. Though women on the Island did hook with rags, the presence of several woolen mills there meant that those could afford it, had access to nicely coloured yarn.

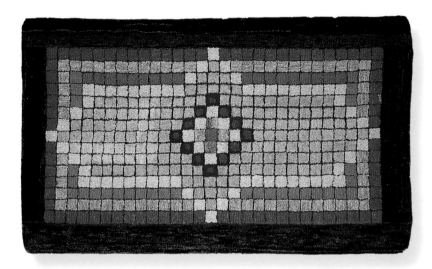

*"Inch Mat," 30 x 52 inches.
This mat is typical of those
done on Prince Edward
Island. The design is varied
by different colours used to
hook the blocks. It was often
hooked, and was referred to
by many names, such as the
inch mat, the sidewalks of
New York, Boston sidewalk,
and the Amherst mystery.
Various areas of Atlantic
Canada have claimed this as
a design that emerged from
their region, however, it seems
to have been a common
pattern in many communities.
Compliments of Cathy
Consentino Antiques.*

In central PEI, women hooked exclusively with yarn once it became available. The presence of woolen mills also meant there was access to the commercial dyes used to dye the yarns.

On the eastern part of the Island, hooking with rags was accompanied by strict regional conventions. Virtually everyone finished their mat with a thin black binding, and all outlining done in the mat was done with black, rather than with navy or dark grey; black was the only acceptable colour.

Dying wool was a common practice on PEI. Both commercial and natural dyes were used for both rags and wool yarn. One story tells that when the local fisherman were bending the birch twigs in water for fashioning lobster traps, the mittens would become dyed a rich dark brown colour. Once their wives discovered the dye bath that this process created, they began to save the coloured water to dye the rags.

It is interesting that, despite its strong tourism industry, no strong commercial enterprise of selling mats to tourists arose on the Island as it did in the other three provinces.

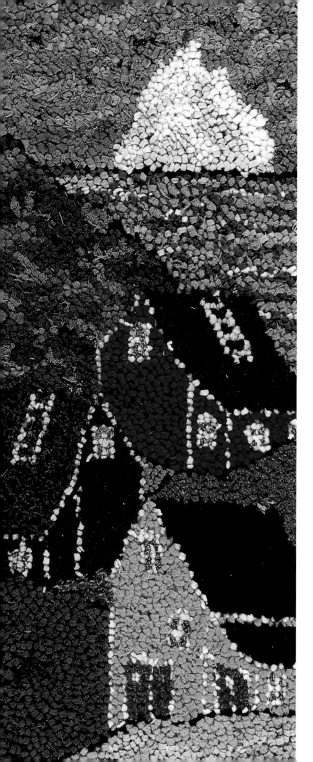

Hooking rugs:
a simple past-time

Basic Instructions

The beauty and practicality of rug hooking is that it is a past-time from a simpler era and therefore requires little in the way of supplies or tools. Traditionally, a hook was made by driving a nail into the handle of a broken tool or a piece of wood. The nail was then filed down to form a hook. Generally, a husband made the hook for his wife who would set up her frames in the kitchen near the stove for warmth. The kitchen was central to the family's life, so she was able to split her time between hooking and looking after her family and her chores. Her frame was also simple, usually four flat boards held together with clamps, balanced on the back of kitchen chairs. The frame was usually leaned against a wall when it was not being worked on. A piece of burlap, usually a feed bag brought in from the barn, was laid out flat and tied or sewn to the sides of the boards. The design on the burlap was often a simply drawn picture of flowers, houses, or animals. Geometric designs of squares, diamonds or triangle were also commonplace. The design was drawn on with whatever was available, sometimes a piece of charred wood from the fire. It was the strips of wool used to hook the design that created their beauty. These were often remnants of clothing worn by her friends and family. Often a shirt or dress was handed down from the oldest to the youngest, being made over several times along the way. It was then put into the rag bag designated for hooking. Dye baths were made by boiling lichen, flowers, or bark on the wood stove. The wool was thrown in and simmered, and salt or vinegar was used as a mordant. As time passed and people became a little more prosperous, commer-

cial dyes were frequently used. Essentially, rug hooking has changed very little from the times of the early settlers until now. It still requires very few tools and can be done during a stormy Canadian winter, even when the electricity is off. That is one of the reasons why I love hooking. I prefer things traditional and simple. My studio is heated by a wood stove in winter, and it has four big windows that flood it with natural light. Still, I doubt I could last three days in the outport Newfoundland that my parents grew up in, and where both my grandmothers made mats as a cherished past-time, as well as part of their daily chores in an effort to warm the cold damp floors.

Today most people start with a kit that contains everything they need to complete their mat. From there, they are free to venture further afield and choose unique stamped patterns. Or, they can venture out on their own and design their own mats. What you need are a hook, a piece of burlap or a stamped pattern, twill tape or rug binding and a frame. You can use a sturdy quilting hoop, a canvas stretcher (often found at artist's supply shops), or a set of quilting or rug hooking frames. As well, you need wool cloth fabric cut into strips between 1/8 and 1/4 inch wide. There are other fabrics you can use which will be dealt with later in this book. It is good to start with a rug that is not too large. A small floor mat of about 18 x 30 inches (46 cm x76 cm) is a moderate size and could be completed in a matter of a few weeks. Some people choose to start on a smaller project such as a hot mat or a chair pad.

Many experienced hookers have a cutter that is especially designed for rug hooking. Most beginners start by taking a 3 x 8 inch (8 cm x 20 cm) piece of wool with a straight edge. The best way to get a straight edge with wool is to make a small cut and then rip it apart. Fold it four times and then cut with sharp scissors along the straight edge. As an alternative to folding the cloth you can wrap it around your hand four times, slide it off and cut along the straight edge. Cut the strips as straight as possible so that they do not tear apart while hooking.

Cutting the wool.

Facing page: "Three Saltboxes," 12 x 30 inches. After a visit to Twillingate, I was excited by the number of old houses in the community. I couldn't wait to get home to draw the simple lines of these houses.

Binding is sewn face to face along the outside edge of the pattern.

The hook is pushed down through a hole in the burlap.

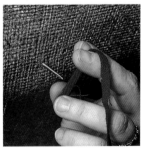

The strip of wool is caught with the hook from underneath the pattern, and pulled up loop by loop.

The binding, usually a piece of 1 to 1 1/2 inch (2.5 to 4 cm) cotton twill tape is sewn along the outer edge of your burlap pattern. That is, the binding is sewn to the outside line of the pattern drawn on the burlap. Do not mitre the corners of your binding when making a primitive hooked mat. It will make the corners appear pointed, rather than the soft, slightly rounded corners that are most often seen on primitive hooked mats. Always leave between 3 and 5 inches (8 and 13 cm) of burlap beyond where your binding is sewn on, so that you have plenty of extra burlap to attach to your frame. If you do not leave enough extra burlap it can be difficult to hook to the edge of your pattern. Then attach the pattern to your frame and secure it in place so that it lays flat and is tight like a drum.

Next take your hook in the hand that you would use to hold a pencil, and a strip of wool in the other hand. Place the strip of wool underneath the burlap and put your hook through a hole in the burlap, lifting the wool up through the hole. The length of wool is drawn completely through as are all wool strips in rug hooking. From there, continue to lift the wool strip through the holes, loop by loop, until the strip is finished. Bring the other end to the surface and clip off both ends with scissors so that they are the same height as the loops.

The simplicity of primitive hooking comes from the fact that there is only one stitch to learn. The basic stitch of pulling the cloth up through the burlap loop by loop will remain the same until you complete your rug. Do not hook in every hole or your rug will not lay flat. Hooking in every second hole is a good guideline. Make sure that the surface is completely covered, and that there are no gaps of burlap showing on either the front (or the back) of the mat. It is also a good idea to tape or serge the outside edge of the burlap you are working with so that it will not unravel.

It is very important to sit in a comfortable position while you are hooking. An uncomfortable hooking position can lead to neck, shoulder, or back problems. You should sit with your back straight, in a comfortable chair, and have your work close to you. I like to pull my frame so close

that it touches me, and I am resting on it rather than leaning over it. Be careful not to sit for too long a time without taking a break. Get up, stretch your legs and wiggle your fingers so that they don't become stiff and uncomfortable. Make sure you have lots of light and are not straining your eyes. Although some people hook for hours at a time and need to remember to stretch, I am at home with two small children so I find that their constant requests keep me on the move.

There are some simple mistakes that many beginners experience but they can be easily overcome with practice. It is difficult often to get the piece of wool up through the little hole in the burlap. When you put your hook down through the burlap make the hole a little bigger by moving your hook from side to side. Working underneath your pattern, you can wrap the wool around your hook and pull the end up through. If when you pull up a loop, you also pull out your last loop, be patient; this happens to most new hookers. Try pulling your loops up a little slower and more gently. It may also help to pull them a little higher. Everyone hooks to a different height, and at first your loops will be uneven and look messy. As you continue to hook you will develop a tension, similar to that which happens in crocheting or knitting, and your loops will even out. It doesn't matter if some loops are slightly higher than others. When your rug is finished, press it on both sides with a very hot iron and a wet cloth: this will even out slight inconsistencies in the height of your loops.

Rug Hooking Instructions

1. Put your pattern onto a frame such as a quilting hoop. It should lay flat and feel drum tight.
2. Cut your wool by taking a 3 x 8 inch (8 x 20 cm) rectangle of wool cloth with a straight edge, folding it four times and cutting it with sharp scissors along the straight edge to create strips that are 1/8 and 1/4 of an inch wide. Shorter (5 1/2 inch) scissors work well for this.

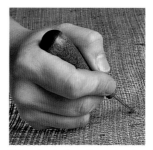

When hooked, each wool strip is pulled up through the burlap, bringing the end to the surface.

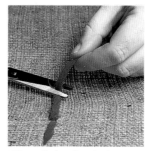

The end of each strip is clipped to the same height as the loops.

What you will need:

- *Rug hook*
- *Rug binding*
- *Burlap or stamped pattern*
- *Frame*
- *Wool cloth strips*
- *5 1/2 inch scissors*

3. Take a strip of wool and hold it underneath your pattern. Take the hook in your free hand and pull the wool through a hole in the burlap. Leave the end of the strip on the top side of the burlap. When you put the hook through the hole in the burlap, make the hole a little bigger so that it will be easier to pull through. Everyone hooks to a different height. Most people pull their loops up to between 1/8 and 1/4 inch (.3 and .6 cm) high.

4. It is a good idea to begin hooking something simple, such as a house or a straight line.

5. There is no knotting or tying involved; it is the packing of the loops together that keeps them from falling out.

6. Do not hook in every hole; if you hook your rug too tightly, it will not lay flat.

7. Keep the burlap tight on your frame as this will make hooking easier.

8. Hooking every second hole is a good general guideline. Continue to hook loop by loop until you reach the end of your strip, pulling the end to the surface. Be careful not to cross the paths of your wool on the back side of your rug. You can hook in straight or curved lines.

9. When your rug is complete, cut away all the burlap except 2 inches (5 cm). Fold these over on the backside of your rug and sew it. If you want, you can use a black cotton twill tape or a 2 inch (5 cm) strip of wool as a binding. This is generally sewn face to face along the outside edge of your rug before you start hooking. This can be done by hand or by machine. Sew the outer edge of your binding to the outside edge of the mat pattern so that it folds away from the pattern. When the rug is completed cut away all but 2 inches (5 cm) of burlap and fold the binding back; roll the remaining binding up under the burlap, then sew it along the backside.

10. Using a hot iron and a wet cloth, gently press your rug on both sides. This will help even out your loops and give your rug a finished look.

11. To estimate the amount of wool you need to complete a section of

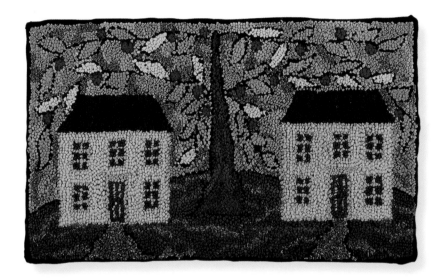

"Willow Behind the Saltboxes," 20 x 38 inches. The background of this rug uses three shades of tan, one of which is a good bit darker than the other two. They are hooked randomly to create a mottled effect. Collection of Heather and Larry Pardy.

rug, a good rule is to measure four times the area you want to cover. In the past, people often did not have enough of any single colour or type of wool to complete a background. This is still true today for those of us who use recycled wools. Women often hooked small areas of colour all over their background so that they could easily add another colour to the background if they felt they were going to run short. This gave the background a mottled effect. Avoid hooking areas left to right, but cover sections here and there before completing the background in case you run short of wool. This way, if you run out of a particular colour you can fill it in with something close. This mottled effect often looks quite quaint and adds a primitive or shaded quality to the work.

Hooks

When I hold the handles of my small but beautiful collection of antique hooks, I can sometimes tell how the person who used it might have held

A selection of antique hooks.

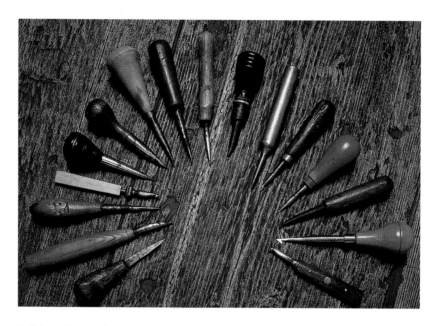

it. It's as though it had adapted itself to the shape of her hand. Sometimes the initials of the owner or a little symbol are carved in the wooden handle. To me, this is a sign that there were more than one of the same type of hook around, or that the owner attended hooking bees where her hook could get mixed up with a similar one. Many of the hooks I have were created by a husband for his wife. They were usually a nail filed down after being driven into a piece of wood that was roughly carved to form a handle. Sometimes an old knife with a wooden or bone handle was fashioned into a hook. I even have a hook that has a brass shell casing as its handle.

The real key to a satisfactory hook is the feel of its handle in your hand, and how you prefer to hold it. Most people tend to stick with the hook that they learn on, though many of us try a few different ones along the way. I can relate to the woman who carved her initials in her hook. She was attached to it; the wood on the handle just felt right. One night

when I was hooking, I pulled the metal part of the hook out of its wooden handle. Rather than give up my favoured hook for one of the dozens of the exact same style that I had stocked in my supply shop, I tried to fix it. I used my kitchen potholders to push the metal shaft back into the handle with a bit of glue on it. I still shiver when I recall the hook rushing through the potholders and jamming into my thumb. After trying to get it out, feeling nauseated with pain, I rushed to the emergency department where my thumb had to be frozen before the hook could be removed. Needless to say, my stint as a shish-kabob with two dirty pot holders taught me to use common sense, not to mention keeping my pot holders clean. The hook you learn on is lovely, but keep an open mind, skip the heroics, and try a few alternative ones along the way. Various rug studios and teachers offer different types of hooks for sale these days. Some common types are the pencil hook which has a long slim handle, or a standard hook which has a 4 or 5 inch (10 or 13 cm) wooden handle with a fine crochet hook in it. The bent hook features a slight angle on the shaft of the hook, while the arthritic hook is designed to ease any pain that might be caused from repeated use. Besides the size and the shape of the handle, there are also variations in the size of the hook itself. I have always preferred a small hook although I use wide strips of wool. There are no hard and fast rules about this, although most people choose a coarser hook when using wider cuts of fabric.

Backings

I have always enjoyed hooking on burlap. My first rugs were hooked on burlap bags just as my grandmother's were. When I began to hook I became interested in the way my grandmother had done her mats. After learning that she hooked on feed bags, I began tracking them down and using them. The danger in this is that you never know if the bags have been water soaked which will really damage them, making them rot quickly. I would definitely not use a feed bag again. The two main types

A. Primitive Burlap

B. Primitive Linen

C. Monks Cloth

D. Rug warp

of burlap that rug hookers use today are: 1. Standard or primitive, which has a looser uneven weave, and 2. Scottish burlap which is of a heavier weight and woven in an even grid-like fashion. The latter is imported from Scotland and is used primarily by traditional hookers who do a lot of fine shading and pursue an even look in their work. Trying to pull heavier or wider cut fabrics through the finely woven Scottish burlap can turn rug hooking into an arduous task. The primitive, which I have always preferred, is more suitable for heavier weights of fabric and for the wider strips used in primitive hooking.

The biggest problem with burlap is that it will deteriorate quickly if it is not cared for properly. Rugs made on burlap cannot be immersed in water as the burlap will rot. Though we know that burlap is a fragile backing, it is true that there are many rugs around today that are 40, 50, or even 100 years old. The Abigail Smith rug described earlier is hooked on burlap and is dated 1860. Many antique mats were hooked on burlap, so there is no question that it does have longevity when properly cared for. Not every rug needs to be created as if will end up in a museum. Sometimes we are just making a mat to decorate our home, giving us some daily pleasure and establishing our time and place in history. It depends on how long you want something to last. Sylvia MacDonald, a well-known rug hooker from Pictou County Nova Scotia, once said, "There's nothing wrong with a little planned obsolescence." Anyone who hooks a particularly bad rug may get some satisfaction out of knowing that it might not outlive them.

Monks cloth, rug warp, and linen are gaining popularity as choices for rug backings. They are generally more expensive but are thought to be of museum quality; they resist water damage quite well and become less brittle over time. A linen material that is similar in weave to primitive burlap, but soft and silky to the touch is one of my favourite backings to work on. It feels like you are using burlap except for a silkier feeling against your skin. Monks cloth is great for very large floor mats because it

comes in widths of 144 inches (3.6 m). However, it is quite stretchy and can be a bit more difficult to work with. Rug warp works better for finer cuts of cloth than is used in primitive hooking. The least expensive— primitive burlap—has a fairly even weave that responds well when a hook is pushed through it. You can make the holes a little larger as you pull up your strip; the threads of the burlap will spring back into place.

Frames

Most beginners start with a hoop or a lap style frame. Many lap frames are made in a rectangular shape, and the backing is tacked to the wood. If you are going to use this method, use upholstery tacks. They are longer and will extend through your hooked areas to the wood of your frame. Some frames have a bent metal material similar to a dog brush, attached to both sides that your rug will stick to. This allows the rug to be easily lifted up and moved around.

When choosing a hoop as a rug frame, get one that is made of hard-wood so that it is strong and can hold the weight of the hooking without cracking. The inexpensive hoops that are available at most craft supply stores can be used; in fact I made my first few rugs on them. However, I went through a hoop for nearly each rug as they crack and are generally not durable if the piece you are working on is larger than the hoop. They are an accessible and inexpensive style of frame for the beginner who is just trying their hand at rug hooking. Four long narrow pieces of board attached at the corners with a set of clamps, like women used in the old days, are usable but not ideal. In this case canvas cloth is attached to the wood so that the pattern can be sewn to the boards. A second option is to attach the burlap right to the board by winding string around the board and through the burlap. With the new frames that are available this is my least favourite method. It is not only cumbersome but it is difficult to find chairs that are a good height for the frames to be laid on for working. Often you end up leaning awkwardly over this type of frame and this can

Antique mat frames and a floor model frame. These are all still used by today's hookers.

Facing page: Four types of backing for rugs.

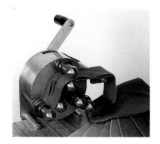

A Bolivar cloth cutter.

Photo courtesy of Bruce Cutting & Grinding

be quite uncomfortable. My absolute favourite frame is the floor model Cheticamp frame that consists of two roller bars attached to a set of legs, with a pair of gears on the ends so you can draw your backing tight. It is similar in design to a small quilting frame or a floor model needlepoint frame. The reason I like this table style frame is that you can sit up straight, pulling your work close to you. It does not have to lay on your lap where it can become warm and heavy. I also find that people who use floor model frames complete rugs much faster because they are unencumbered by the burden of holding their work, and can focus on hooking. Your choice of frame will determine the position that you sit in while hooking, so remember the importance of being comfortable; your rug will hook up much more quickly.

Cutters

When people first started hooking, all the cloth was cut by hand using scissors. This is still true for many people today. Even though I have several mechanical cutters, I still cut some wool by hand for every rug, using a pair of inexpensive but sharp 5 1/2 inch (14 cm) scissors. I like the process, and the primitiveness, of the effect. Hand cutting seems to work better for certain wools. Fine wools, sweaters, jersey and some wools that are loosely woven seem to hook up better when you cut them a little wider using scissors. Melton cloths, and thick heavy coat weight wools, are difficult to cut into narrow strips with scissors, but strip easily with most mechanical cutters. Rotary cutters, designed for quilters, are also used by some hookers to cut their cloth into strips.

Mechanical cutters imported from the United States are sold at many supply shops throughout the region and from companies in the U.S. When a group of women formed Spruce Top, a partnership selling hooked rugs and rug hooking supplies on the south shore of Nova Scotia, they wanted to sell as many products made in the region as they could. One of the original partners, Joan Bolivar asked her husband Bruce to

make a wool cutter to sell in the shop. After some persuasion, they began a process of experimenting with design to create an excellent machine. The Bolivar cutter works on a scissors action by turning the handle. Each machine has three sizes of blades that can be easily changed.

Gathering the cloth

As you can appreciate from the different styles of mat hooking discussed in the previous chapter, people use many types of fabric in their mats. Over the years mat makers have used woolen clothing, silk stockings, nylons, t-shirts, woolen yarn, and whatever else they could find to hook with. Some contemporary hookers have been known to snip the hair off their pet to hook into his portrait, use wool straight off the sheep, or include a few pieces of seaweed to add a little texture. This is not suprising for a craft that used what would otherwise be thrown away. One of its purposes was to give a new life to that which could no longer be used. I prefer to use wool cloth, and do so in all my mats. However, I do like to keep an open mind, so hooking with other fabrics will also be discussed here. In some areas wool may be scarce, and it is better to hook with any fabric than not to hook at all.

Wool cloth

The absolute best type of fabric for rug hooking is wool cloth. Most types of wool are soft and easy to work with, as well as durable and long lasting when used in a floor mat. Some traditional hookers choose to use new wool cloth straight off the bolt, though most of them do also use recycled wools when they are of a similar weight. As a primitive hooker I like to use recycled clothing, mill ends, old blankets, and whatever remnants I can find. Even the purist primitive hooker, however, will use wool straight off the bolt when it is reasonably priced, or expertly dyed. Once, while teaching with the Newfoundland and Labrador Rug Hooking Guild, I came across a piece of wool dyed by Germaine James, the

teacher in the next classroom. I had just driven six hours across the centre of Newfoundland, and when I saw the rich dark greens and browns, "Terre Neuve" came to mind. Germaine's lovely bit of wool was used to hook the map of Newfoundland in the centre of a circular rug, that has a border of fish, net needles, and dories. The wool really helps to make the rug what it is. In choosing cloth, don't create too many rules for yourself. Keep your mind and your wallet open. If you are going to spend your winter hours making a rug, it is worth buying that choice bit of fabric, or your favourite backing, such as a piece of linen that looks and works like burlap but feels like silk.

I prefer 100 per cent pure wool, but any article that has 70 to 80 per cent wool in it works well and retains the feel and texture of wool. Recycled clothing is available at the numerous second hand stores that are cropping up everywhere. When picking out articles of clothing be sure to check the fabric content. I have found that thin wools, such as those used in men's suits, are difficult to hook with because they fray. They do have uses, which will be discussed later. I prefer the wools used in ladies' skirts, blankets, or coats. Check the linings to make sure that they are removable and are not glued to the wool fabric, as glued linings can ruin the wool, rendering it useless. Today there are many acrylics available that look like and feel like wool. They can fool even the most experienced hooker. A common test, do not attempt it in the store, is to light a match to the edge of the garment. When wool burns it smells like hair burning. This can help you determine if the fabric you have is wool. Mill end remnants are not always accessible but if you can find a woolen mill or a clothing factory, they usually sell remnants for a small price. Many rug hookers do not like to use knit wool fabrics, such as sweaters, because they are sometimes loosely woven, and can unravel when they are cut. I have found that they can be very useful if you hand cut them wide enough, so they don't unravel, since they add an interesting texture to your mat.

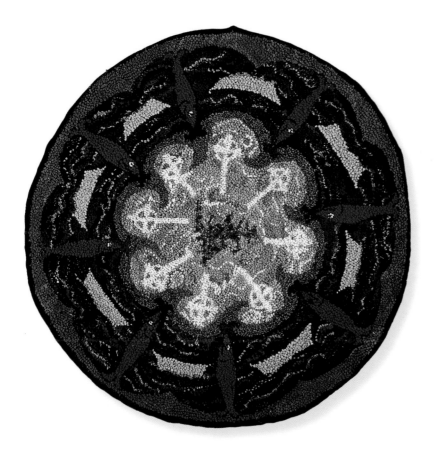

"Terre Neuve," 48 inches in diameter. The celtic crosses in this rug lie upon the ocean as a symbol of lives lost to rough waters. The wool used to hook the centre—the map of Newfoundland—was dyed by Germaine James. The rich greens and browns add a lot to the mat creating an interesting focal point. Collection of the artist.

Once you buy your fabric, the next step is to wash it in the washing machine. Clean wool is important because it is easier (and more hygenic) to use. Once your rug is hooked it is more difficult to clean. As well, many hookers agree that cleaning your wool helps cut down on problems with moths. When I have a large load of fabric to wash, I tear the linings out of the clothes first to decrease the bulkiness of the fabric. I then dry everything in the dryer because I like the fluffy feeling that this gives the wool.

Many people hang the wool to dry and this also works well. When tearing wool apart, it is useful to make a small cut at a seam to begin ripping. Expect quite a bit of waste. With skirts I find that the work is done once you cut the waistband off and remove the buttons and/or zipper. The fabric can then be folded, or rolled and stored. It is preferable to store it where you can see the colours and textures you have on hand at a glance.

The first thing to do in your efforts to gather wool is to let your family and friends know that you are looking for it. It is often surprising how much they can come up with. Never refuse any offers of fabric; if it turns out not to be wool you can give it to charity. If it is not a type of wool you like, pack it up and send it to me; there is always someone who can use scraps of wool that you might not want.

One of the things I love about gathering wool is the way it comes to you. Once after reading a brief note about my work in *Harrowsmith* magazine, an elderly woman from Ontario began sending me boxes of remnants that she had saved. I got some in the fall with a note saying that in the spring she would have her son go up to the attic to retrieve another box. Several months later, the second box arrived, like a gift out of the blue, with nothing requested in return. This is how wool arrives, often from someone who has decided that she will not hook that mat that she always planned to. Rather than throw out the wool dresses that her little girls wore, or her son's first communion pants, she passes them on to me. Waste not, want not; everything can be used. Sometimes wool is dropped off at my door by other rug hookers who have over-collected and have decided that they will never use all they have. It is through using fabrics like the army blanket from the base where my father worked all his life, the coat of a friend who passed away, or a bit of wool that has been given to me by someone I love, that I can create more meaning in my rugs. Many of the old mats made by women out of their families' clothes, were a record of their family histories.

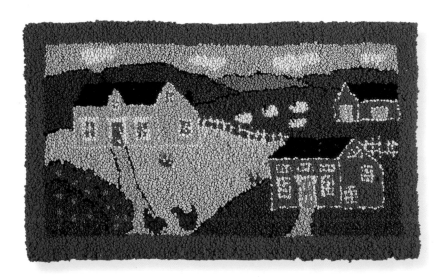

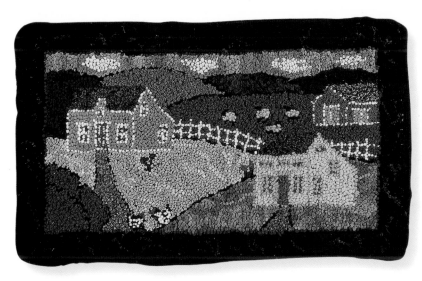

"The Family Farm," hooked with yarn, and "The Family Farm," hooked with cloth. The contrasting methods achieve quite different results.

Hooking with Yarn and Other Fabrics

The instructions for hooking with yarn and other fabrics are the same as the general instructions for hooking. You should make sure any fabric that you use is clean and odour free before you start to hook with it. There are slight differences in the preparation of the fabrics which are described below.

Yarn

Hooking with yarn is quite nice in that there is a wide range of colours available and yarn requires little preparation. Those who enjoy dying wool can purchase natural wool and use traditional dying methods to get a wider range of shades and colours. Where possible, 100 per cent pure wool yarn should be used. Acrylic and polyester yarn can be used but they are not as pleasant to work with, and the completed mat seems to lack the warm look of those done with wool. The thickness of the yarn you choose should be determined by the size of the weave in your backing material. Thicker plys, and chunkier yarns, can be used on primitive burlap, monks cloth, and linen. Finer single or two-ply yarns are good for hooking on backings that are more tightly woven. For working with yarn in a twisted skein, untwist the skein, and cut it at one end so that you are left with 4 feet (1.2 m) long strips of yarn that can be hooked individually. This is easier than balling the wool, and prevents it from becoming tangled. Wool that comes in a ball can be used straight from the ball as if you were knitting, The major drawback when hooking with yarn is that it lacks the variety of texture that you can get with cloth. Otherwise, it is a matter of taste. Some people prefer a more primitive look, while others like the even patina that can be had when using yarn.

"Geometric," 30 x 50 inches. Hooked with hosery, yarn and dyed burlap. Compliments of Cathy Consentino of Timber River Antiques.

Nylons

Betty Laine, a rug hooking teacher from Thornhill, Ontario has a great deal of experience teaching people throughout the United States and Canada to hook with nylons, or pantyhose. She stresses that the easiest method for cutting nylon fabric is to cut the toe off the nylons before cutting across the round. Then stretch the round strip to give it length and cut the circle so that it forms a strip. When hooking nylons, you need to be careful to make sure that you pull the loop all the way through your backing as the stretched nylon will shrink back to its previous shape. As well, the strip of nylon will curl, so you must hold it flat while hooking. Betty, who was once a purist about using all wool fabric, has found that she can do anything with nylon that she has done with wool. Nylon takes beautifully most commercial dyes that are used for rug hooking, and bleaches out to lovely shades of yellow or pink. One of the great things about hooking with nylons is their availability. In some areas wool can be difficult to find, but we all know women with runs in their stockings!

Cottons, t-shirts and other fabrics

Many people who sew, wonder about hooking with cotton and other fabrics. Though I have met the occasional person who uses cotton, most people find it hard and uncomfortable to work with. Cotton knits, of course, are somewhat softer and can be used more easily. The truth is almost any fabric can be used for hooking. In the olden days people took apart the burlap and hooked it. What really matters is finding a fabric that you enjoy working with. Find one that is durable and has longevity, especially if you are putting your rug on the floor. Gloria Crouse, in her book, *Hooking Rugs: New Materials, New Techniques*, discusses using many different fabrics and yarns in contemporary rug hooking.

Caring for Hooked Rugs

Once you finish your hooked mat, it is important to take good care of it so that it will last a lifetime. The most durable backings are linen and monks cloth but many mats are still hooked on burlap. All of them when properly cared for are strong and long lasting, but burlap is definitely the weakest. A hooked rug should not be thrown in the washing machine, immersed in water, or dry cleaned. Years ago, people would lay their rugs face down for a couple of hours on new fallen snow to freshen them up. I still like this method and use it every winter. Each washing allows some of the dirt and dust to fall out of the rug. I also vacuum my rugs and gently shake them out. I never use a strong power nozzle on them, or beat them. Shaking an old mat can damage the backing, some are so weak that even a gentle shaking will break the burlap that the rug is hooked on. Many people clean their mats with cleaners that are formulated for washing carpets. There are even some cleaners on the markets that have been especially designed for hooked mats, and are available at some rug hooking supply shops. I like to use a damp cloth with a little mild soap. I wring a wet cloth out so that it is just damp, so that it won't

"Cat in the Vines,"
52 x 20 inches. Oak leaves,
star-shaped flowers, and a cat
caught in the vines is a simple
and fanciful primitive rug
that has worn well on the
floor over six years. It
remains in excellent condition.

soak the burlap or backing, and I gently wipe the top side of the mat, laying it flat to dry. Spills and stains should be soaked up immediately with a dry cloth. Try to keep any dampness and water on the surface of the mat so that the backing is not effected by water damage. If you have a mat with a hole in it, or one in which the backing is worn out or rotten, the most straightforward way to repair it is to neatly sew a piece of backing to the underside of the mat. Remove the loops that are worn out and hook on the new backing until you have filled in the hole. You can cover up several patch jobs by sewing a new backing to cover the entire back of the rug. The new backing should be a loosely woven material so that it does not trap dirt between the mat and the new backing and eventually cause more wear and tear. This sort of repair job can be very difficult if the backing is in very poor shape. If a rug is a family heirloom, or has significant personal or monetary value, it might be wise to consult a professional in antique rug repair.

You can save wear and tear on your rug by laying a rug liner underneath it on the floor. When you store your mat for long periods of time it should be rolled, not folded and the good side should be facing outward. It can be wrapped in cloth but not plastic, as the fabric should be allowed to breathe. With proper treatment your mat should last a very long time, perhaps for generations.

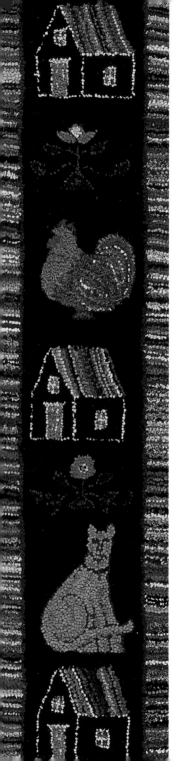

Types of design

Geometric Designs

Some of the earliest forms of primitive hooked rugs were geometric designs. They are an excellent beginner project because the pattern is simple to create. With a metre stick and a black permanent marker (I have always found Sharpies to be the best because they do not run) draw the sides of the pattern to the size of rug you want to hook. When you look at old geometric mats you can sometimes see that a common item such as a dish, an iron, or a sea shell was used as a stencil or template to create the design.

You can create blocks, triangles, diamond or any type of repeated pattern to create your own geometric design. Quilt patterns have long been a valuable source for finding geometric designs. "Hit and miss" is often used in geometrics. This involves creating a series of stripes of different colours, and is great for using bits of leftover fabric. Carol Wood Oram of Cumberland County, Nova Scotia uses a lot of "hit and miss" in her designs. She gathers together three times as many colours as she thinks she might need, then begins to eliminate the wools that do not seem to work. Often these are the lightest and the darkest shades so that she is left with the middle tones. She finds that a mixture of plaids, tweeds, solids, and checks of different weights works well. She tends to create a theme based on colour rather than using whatever she happens to pull out of the closet.

The real trick in hooking a geometric is your use of colour. It is easier to ruin a simple pattern than it is to make it attractive. Look closely at your colour choices to make sure that they are working together rather than against each other.

The geometric mat is so simple that there is not a lot of detail to discuss. However, that does not mean it is unimportant. Some of the most beautiful old mats that we see at auctions and on the floors at old family cottages are geometrics.

*Geometric design, 22 x 30
inches. Designed and hooked
by Carol Oram, this is the
simplest of geometric designs.
The four corners are squared
off, with a border around the
squares, and again around the
entire rug. It is hooked in a
traditional hit and miss style.*

Florals

In competition with geometrics as the most popular choice of design
are florals. In some houses florals were the only type of design ever
hooked. The most common pattern was the one my grandmother used, a
rose in the centre surrounded by a diamond, and roses, scrolls or leaves in
each of the four corners. Sometimes the roses would be hooked higher
then the background of the mat to form what was commonly referred to
as "riz roses." Today this type of hooking is often called "sculptured."

The Victorian scroll was a common element that was often mixed with
floral motifs. Leaves, berries, twigs, and branches were also used to
enhance these designs; these elements were often used as a border for
sprays or baskets of flowers in the centre. One of the largest and oldest
rugs in the collection of the Canadian Museum of Civilization features a
flower basket motif. A basket of flowers centered on a mat, with or
without a border was a common type of floral.

*Facing page: "Hit and Miss
Runner," 18 x 72 inches. A
playful rug that demonstrates
the "hit and miss" technique of
using up bits of leftovers; this
technique was popular
throughout Atlantic Canada.*

Right: This simple rose pattern, 24 x 42 inches, was hooked by Eliza Adelia Williams Scott in the 1930s in Pugwash Junction, Nova Scotia. It is now owned by her great grandson, Daniel Walker.

Below: "Antique Posy," 19 x 34 inches. The flower basket is a traditional design that has been used in many variations over the years.

Many traditional rug hookers who have emerged through the Rug Hooking Guild of Nova Scotia enjoy hooking floral designs. The wools they use are often a skirt weight wool, cut into strips smaller than 1/8 inch (.3 cm) and dyed in up to six shades of the same colour. This type of "tapestry" hooking gained popularity with women in Atlantic Canada and is prevalent today.

Abstract

The abstract design is suitable for the beginner and the most experienced hooker. Its freedom of form allows you to express yourself through the use of colour, in a way quite different from the geometric style described above.

Sometimes an abstract can be created by putting together an assortment of wools in different colours, textures, and sizes and then separating them at random to be hooked in small free form shapes to fill the entire area of your mat. It is important to avoid too many bright colours, unless you want to create a very vivid effect. This is a great way to use bits and pieces of wool.

This method is even more successful when you pick a theme or colour scheme. Doris Eaton, for example, has created a body of wonderful abstracts that focus on sea life. When she decided to create an oyster rug, she bought an oyster at the market, to provide her with the inspiration she needed to complete her mat. (Yes, you can buy a single oyster!) Using the oyster as a starting point, Doris selected from her fabulous collection of rags those that were reminiscent of the shell. In her view, "An abstract becomes a thing of colour, contour and texture; it takes on a life of its own. You need to be open, to let it happen. Not everyone feels they can do this but you must work at it. I sometimes hook and unhook 'til I get it the way I like it. I don't know what that is until it happens." This is excellent advice from someone with years of experience.

Doris Eaton's "Mollusks" rug, and the shells that inspired it.

If you want to create an abstract, visualize the design in your head at first. What is the image that you want to create? Sketch it out with colouring pencil, or choose an object for inspiration like Doris did, and select colour from your basket of rags. Choose the bits of wool that remind you of the colour and texture of the object or image. Examine your drawing or object closely and ask yourself these questions: What is its shape? Are the lines that define it parallel lines, circles, or horizontal lines? This will determine the direction in which you will hook. Begin hooking, and follow your instinct. Stay in touch with feelings you experience. It's not easy, but it might be worth it; and wouldn't it be nice to know if it is.

Animals

There is a good deal of interest in hooking animals. Many guilds offer classes and workshops because so many people have a pet that they would like to recreate in a mat. This is not a new phenomenon though. The show Hooked on Rugs, demonstrated that animals and pets have always been a favourite subject of hookers in Canada. In the primitive mats that were featured in the exhibition, animals were often executed by

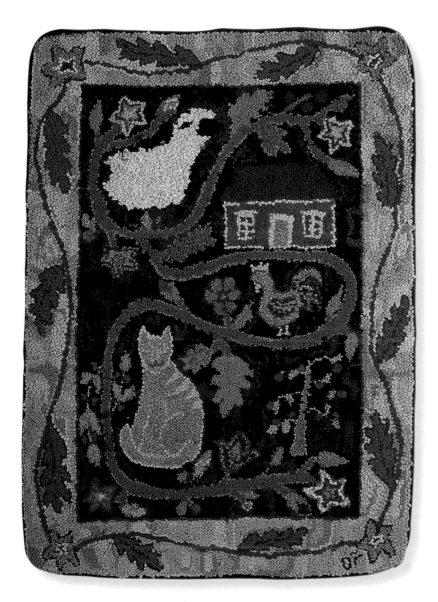

*"Oak Leaves and Animals,"
34 x 48 inches. This rug uses a
playful border and a mottled
background of mixed wools to
show off a sheep, a rooster, and
a cat. Collection of the artist.*

simply outlining their shapes a darker shade and filling in with a lighter one or vice versa. Often a single or very few fabrics were used to create the image. When not re-creating the animal in its natural setting, the rugs were often embellished with borders or flowers to make them more decorative.

Today with a much wider selection of fabrics available, we can make animals slightly more realistic while still maintaining the primitive style. Rather than trying for too sophisticated an image, the primitive hooker will outline the shape of the animal in a reclining, or simply moving, stance. The bent leg of a dog or horse, is a good example of showing this type of simple movement. The direction of hooking should reflect the shape of the animal. For example, the curved back of a cat should be hooked in curved lines, while a stretched leg would look better hooked in long straight lines. A simple approach is to tear animal shapes out of large sheets of newspaper. Spend only a minute or two on each animal so that instead of trying to make the shape perfect, you catch the spirit of the shape. First, tear out the shape of a dog, or a cat. The newspaper stencil you create will be reflective of the primitive animal shapes found in early mats.

It is important that there are contrasts between the colours in fabric used for the outline, the inside, and the background so that the animal is distinguishable. Tweeds and plaids are particularly useful to give the effect of fur. Sheep wool, natural or dyed can also lend an important textural quality to the rug. Sometimes bits of velvet, real animal hair, or whatever, will lend the right textural quality can be used as highlights in the fur.

Simple primitive images can also be executed with one or two wools. One wool can be used to outline the animal, the other to fill it in. If you like, a third wool can be used to highlight areas. The facial features are usually shown by simply outlining them.

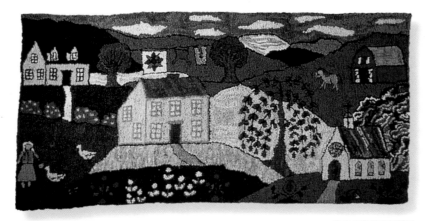

"Village," 58 x 28 inches. One of my earlier rugs, "Village" depicts a simple way of life—quilts on the line, ducks in the yard, and a church down the path. Collection of the Art Gallery of Nova Scotia.

Photo by Geri Nolan Hilfiker

Pictorials

According to Lucien Oulette, curator of the exhibition Hooked on Rugs, pictorial rugs appeared somewhat later than the geometric and floral designs that predominated before the turn of the century. Though they may have appeared later than other types of designs, the popularity of pictorial has certainly endured. Primitive pictorials often feature simple landscapes, houses, boats, and scenes of daily life. Some attention is paid to artistic rules of perspective. Because of the bulkiness of wide strips of wool, it is sometimes impossible to re-create an activity or image perfectly to scale. Often, in a primitive pictorial, images of people appear larger than they should according to the rules of perspective, so that you can see what activity they are engaged in.

One of the most common pictorial rugs depicts a person's home. Whether it is an old homestead, a cottage, or their current dwelling, homes have been one of the most prevalent subjects of pictorial rugs. When not shown in their actual setting, borders, a common element in so many mats, are often used to adorn them.

"The Seven Sisters," 48 x 70 inches. I am the youngest of seven sisters, and this rug symbolizes our relationship with each other. The border of Irish Ivy picks up the colours of the foilage in the centre of the rug. The taupe background in the border uses the same wools as is used in the faces. Collection of the artist.

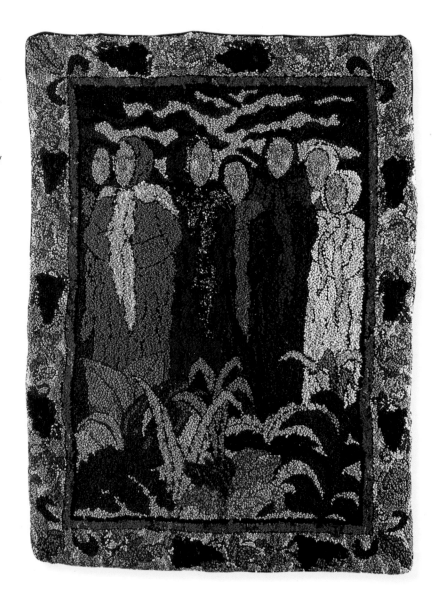

Borders

Borders are a common element of design in many old rugs. A tradition in many mats was to hook four or five rows of black around the edge of the pattern. Not only did this create a pleasant effect, and provide a frame for the mat, it had a practical purpose as well: it was the edge of the mats that wore out first. At the first signs of wear, the row of hooking that was unravelling could be removed (if it was unrepairable) and the mat would still have a nice edge.

A good border can make a mat, and an unsuitable one can ruin it. Most borders are between 2 and 4 inches (5 and 10 cm) depending on the size of the mat. In some cases the border can be the main subject of the mat, with its centre being a mixture of mottled colour. When a border is meant to enhance the design in the centre of a rug, it will usually contain some of the same shades and colours used in the centre design. As well, different colours that contrast nicely with the centre can also be included. The border should act as a frame for the subject in the centre, and though it can be interesting in itself, should not compete with the focus of the rug. Traditionally, the elements of a border are intertwined for organic types of motifs. A single inanimate object is often repeated over and over again, or repeated alternately with other inanimate objects.

"County Fair," 12 x 27 inches. A celebration of life in the country with a plain, solid border. Collection of Joan and Tom Stephenson.

A border is most often separated from the centre of the mat with one or two rows of hooking in a distinct colour. However, like all of the indications and suggestions in this book, it is not a hard and fast rule. The border can also be of a solid colour or tweed, when it is not decorative. Though dark colours such as black and navy are frequently used, I have used just about any colour at one time or another with varying degrees of success. Mostly I find that a colourful pictorial rug is best framed by a border of a dark colour so that the picture, rather than the border becomes the lively focus of the mat.

Shapes

Rugs do not have to be the traditional rectangular shape with which we are so familiar. The design of a rug can be enhanced by simply varying the shape. Soften the angles to curves to create ovals and circles. Experiment with squares and octagons; there is no limit to types of shapes that can make great rugs. Imagine the endless possibilities of putting a border on an octagonal rug!

Since I began making rugs in 1990, the freedom of escaping the traditional rectangle has been the most exciting thing that I have encountered. After watching a friend paint ships on shaped pieces of board to be hung above a door, I realized that I could vary the shapes of mats. My first shaped mats were fairly small, about 12 x 30-40 inches (30 x 76-102 cm) and were designed primarily as door toppers. As I continue to experiment, I have created very large mats 3 x 6 feet (.9 m x 1.8 m) with shaped tops as well. If you decide to make a shaped mat it is important to make sure that your edges have soft contours and not jagged or sharp ends because these are difficult to bind. For example, if you are hooking a row of houses which meet in a "V," binding would be difficult without cutting away nearly all of the burlap, creating a weak spot in your mat. It would work better if you put a small hill, or some bushes behind the

"Foggy Day in Branch,"
34 x 34 inches. I wanted to
show the fog hanging over the
flat topped houses without
showing the sky. I grew up in a
community that was foggy
nearly every morning of my
life. The fog still makes me feel
warm and comfortable. The
field in the foreground, and the
waves, are hand cut.
Collection of the artist.

houses as this would round out the contour and make the mat be easier to bind.

I have experimented with putting latex or white glue on the back of the mat and cutting to the very edge. This is a tricky procedure and I have not had a lot of success with it. The main reason I avoid this now is because you substitute the soft texture of wool on the backside of your mat, for a more plasticized texture. I dislike the way this looks and feels, as well as the fact that it takes away from the primitive appearance of the mat. Secondly, if you ever need to repair the mat, the presence of a latex backing can make it difficult to repair. Recently I was making a small hall

runner with an oak leaf motif as the main design. Wanting to give the mat
something special, I began experimenting with the shapes. What emerged
was a soft wavy pattern on each side of the runner, instead of the tradi-
tional long narrow straight sided mat. A rug can be shaped on all sides as
long as the angles do not become so sharp that it is difficult to bind.

Creating a door topper, or a shaped pictorial, really involves looking at
the design you want to hook and determining how you can give it a
shaped edge without making it too difficult to bind. Though traditional
black binding can be used, the easiest method is to cut all but 2 inches
(5 cm) of the excess burlap away, and simply fold and turn the burlap
over to create a 1 inch (2.5 cm) hem. Sew the hem along the backside of
the mat.

Other Ideas for Hooking Rugs

There are a lot of applications for hooking. I have seen hooked purses,
pillows, capes, chairpads, stair treads, liturgical shawls, vests, and even
bedspreads. But as in all crafts, some things seem to work better than
others, especially with primitive hooking which is quite heavy. Finer
types of tapestry hooking can be applied to garments without weighing
them down, so that they become uncomfortable. Chairpads are the most
common variation of the hooked mat. Black cotton twill tape can be used
as a binding, or the extra burlap can be turned over and sewn along the

back of the rug. They are often lined on the backside with a coordinating fabric. They are usually tied with a little extra binding to the back corners of the chair. Stair treads are a series of separate little mats attached to the steps of a set of stairs. They are usually about half the size of the step, and centered on it. They should be bound like a floor mat so that the burlap is protected from wear. As well, they should be secured properly in place to avoid slipping or other accidents. It is better to tack them down, though this may damage the steps, because if you glue them the little rugs can be difficult to repair over time. Glue will also cause some damage on the surface of your steps. The pattern for a set of stair treads can be the same for each tread or they can differ from each other. Pillows with hooked tops, add an extra dimension to a couch. The hooking itself is often comfortable enough to lay your head on. You can hook the pillow in the shape that you want; when you are finished hooking leave some extra burlap so that you join the pillow to it's backing by binding it with a 2 inch (5 cm) wide strip of

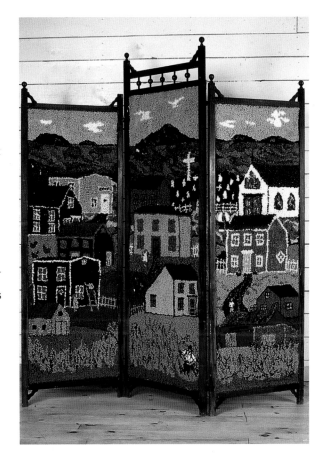

coordinating wool. Bind it on three sides, slip a pillow form in the pocket and continue to bind. The possibilities continue from coasters and tea cosies to bed spreads and room-sized carpets. If you are doing something that is an unusual shape or requires a bit of finagling, be sure to plan the steps out in advance. Leave lots of room for the changes that you will need to consider to make your rug fit the new application.

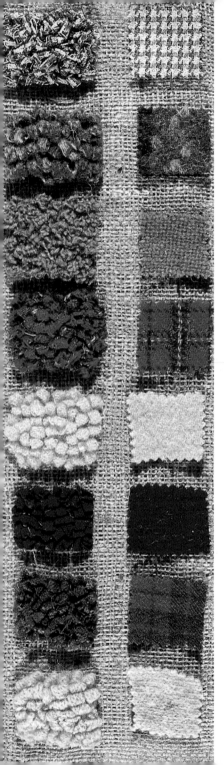

Colour and texture
in primitive rug making

Colour

Whether you like to design your own mats or you prefer to use stamped patterns created by others, you can engage your artistic skills by using colour and texture freely throughout you mat. This is one of the great beauties of mat making. When using a pattern, your choice of colour and texture expresses the way you feel it should be executed. A stamped pattern when hooked should reflect the vision of the person who makes it. Although two patterns may be similar, an individual's use of colour and texture makes them unique.

There is a lot of technical information on colour available, as well as many good books. A good colour wheel, for those who like to take a formal approach to using colour, is available at art supply stores. I have always found that an informal approach to colour, one that applies some trial and error and respects your own judgement is a more natural approach in rug hooking. Although respecting your own judgement about colour is difficult for many beginning hookers, it is important to learn if you are to enjoy the craft. I find that initially you might work with a teacher, or a friend to help you select a colour scheme. Remember it is your mat, and most importantly it should please you.

If you hook something that doesn't please you, you can always unhook it and try again. Primitive hooking should involve some trial and error but be warned, I have watched some people hook and unhook an area repeatedly. They become so caught up in getting the perfect look that nothing pleases them. If you are having a problem finding the right colour for an area, leave it for a while and focus on another part of the mat. Going back to it later may mean seeing it differently. I have also found that when I cannot get the colour of a particular area to work, it is because I have chosen the wrong colour for another area, and it is that area that needs changing. Remember to look at your mat as a whole and not to become too focused on one object in the design. It is the total

picture, the complete feeling that comes from a selection of colours working together that will make your mat beautiful.

When you choose your design, it is a good idea to think about the colour plan before you begin hooking. Decide what impression you want the rug to give. Is it one of an old antique mat, or a bright and cheerful contemporary rug? You can then look at colour schemes in other rugs, paintings, fabrics, pieces of china, or whatever takes your fancy. If you see something you particularly like, note the individual colours that were used in it. You may want to use these as they are, or mix them with some other tones to get the feeling you are after in your mat. Another excellent idea is to take your pattern to your stash of rags. Begin laying the wool cloth on the mat where you think you might like to hook it. This can give you a good idea of what the fabric will look like hooked, and what colours work well together. Be sure to pick the colours for your mat during the daytime, using lots of natural light. Colours can look quite different at night under lamp or ceiling light.

Using tweeds and plaids is a great way of pulling the colours of a rug together. Sometimes you can find a piece of wool that contains a few, or even all, the other colours that you are using in your mat. When they can be found, they can really help pull a rug together. Another way of doing this is to combine several wools that you are using in different parts of the mat and use them together in another part of the mat. For example, in a simple pattern of a house with a border, you could take the wools used in hooking the house, mix them together and hook them randomly as the border. The house might be tan, with a tan tweed roof, outlined and hooked on a dark green background. The border could then be hooked with both the tan and the tan tweed mixed, for a mottled, old fashioned effect. Mixing colours in this and other ways is common in primitive hooking. In the old days, women often did not have enough of one particular colour to complete a background so mixing wools was an effective answer. This is still the case today for the primitive hooker who

Facing page: Swatches of wool cloth and samples of what each would look like hooked.

is gathering bits and pieces of wool from various sources. Over the years, I have read many times that one should avoid using really bright colours in mats made for the floor. Very bright colours sometimes appear as if they are jumping off the mat. I myself prefer very bright colours to be used in moderation, but I recognize that this is a matter of taste rather than a rule of hooking. Sometimes a combination of bright colours can make a wonderfully playful rug. As well, bright colours can be toned down when hooked together with a darker shade in the same area. For example a bright blue, hooked with a black and a navy, gives a dark mottled effect with bits of light in it. This can be great for a night sky, a border, or a background.

Primitive shading needs to be simple and uncomplicated. You are not trying to approximate painting. Rather you are trying to distinguish two parts of the same object from each other so that it gives the appearance of light falling on it. It can make your rug very interesting, giving it depth and dimension. Remembering that objects are rarely a single colour because of the way light hitting an object creates some shading, can be helpful if you want to do some simple shading. For example, if you are hooking a primitive rose, you might want to take three different shades of red and mix them together. After outlining the rose, you can hook the reds randomly throughout the rose without thinking about it, and you will get a primitive effect. Remember that in primitive hooking, you are not trying to create a perfect, realistic image of a rose. In primitive hooking, most areas or objects are simply outlined, and colour is used to separate objects from each other. A leaf is often outlined in dark green or black before it is filled in with a medium green. This outlining makes it distinct from the background colour of the mat. A good colour sense may come naturally to some, but it can certainly be developed and enhanced in those who question their own ability to make a mat that works. I have always found it helpful to examine carefully the colours of the world around me. This has certainly broadened my sense of what things are

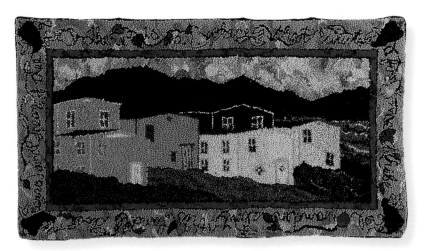

"There Is a Place That Waits For Me," 64 x 32 inches. This rug is about people who have a place they love, and although they may not live there, they dream of returning there. This rug has a lot of primitive shading in the field, sky, ocean, and in the background hill. It is also an example of writing words in a rug. Two rows of hooking should be used when writing words, so the letters keep their form, stand out, and remain readable. Collection of Ruth and Jonathan Nichols.

what colour. The sky can be shades of grey, beige, mauve, rose, orange, blue; the land can be green, brown, tan, grey, gold—and these are just the common, more realistic colours. A good activity to expand your sense of colour is to start keeping a list of the different colours of fields, or trees that you see over a two-week period. You will probably be surprised at the variety of colours that you encounter. The fact is, you are creating a mat and you can use any colour for any object to reflect your own reality. Once a mat maker hooked the fields in her pictorial rug a deep, luminescent purple. I asked if she was trying to depict a field of flowers and she said, "No. It was the only colour I had." Her rug was still delightful and fun, even more so because it had her personal stamp on it. Try to be free with your use of colour, close your eyes and imagine what you want your pattern to look like hooked. Then, using any resources available, your stash of wool, your friends and teachers and their stashes of wool, try to turn that vision into a rug.

Suggestions for using colour

In primitive hooking, wools are often mixed together to achieve an effect rather than undertaking the more complicated dying methods used in traditional hooking. To do this, several shades or colours are mixed together and hooked randomly. The amount of each shade will vary depending on the tone you want to create, i.e., use more of the brighter colours for a lighter effect, etc. It would be impossible to document all the possible mixes for objects that a person might want to hook. However, it may be helpful to present some common ones:

Night Sky: Dark navy, bright blue, and black. For variations, substitute purple, dark grey, dark navy tweed, or medium dark blue. You can create the effect of stars by hooking small spots (i.e., three or four loops) of yellow, white, or a silver gray.

Faces: Naturally the colours you choose will depend on the colouring of the race you are trying to depict. For a Caucasian, you could choose a mixture of three different shades of tan, a light, a medium, and a darker. Use either the lightest or darkest to highlight facial features. A pale pink or cream wool can be substituted for either of the shades of tan.

Skies: Skies are more complicated, depending on the type of day you are portraying. A grey or foggy day effect can be achieved by taking several shades of grey and mixing them with some grey tweed. Several shades of blue can be mixed for a clear sunny day. White or a blue heathery tweed can be added for clouds. Hook small areas of colour to create a patchwork effect. The effect of clouds can be achieved by hooking patches of white in irregular (not oval) shapes. For a more natural effect, do not outline the clouds.

Oceans: My favorite ocean mix is a solid light blue, a light grey tweed, a mid blue, and a medium blue tweed, with a little white to accent the waves. Hook oceans in solid wavy lines from left to right for a realistic effect.

Flowers petals: Take two shades of one colour for smaller petalled flowers, or hook them in a solid colour. For larger petalled flowers you

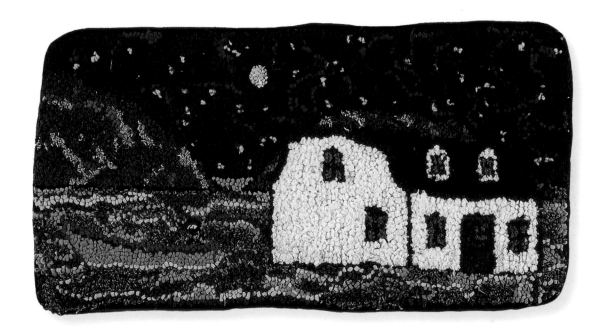

may want to use three shades. For example, a sunflower looks great hooked in with a pale yellow, a bright yellow, and a gold mixed. My favorite roses mix burgundy, bright red, and a dark red together.

Houses: I generally outline the house in a solid colour. I then hook the body of the house in a solid colour (tweeds or plaids can be used to emulate stone or brick). Next, I fill the insides of the windows in with a complementary tweed, and use a solid dark colour or a tweed for the roof. There are many variations on this approach.

Background hills: I find that mixing a blackwatch plaid (navy and dark green) with a dark forest green and a very dark khaki green works well.

Foreground fields: Lighter and medium greens are my preference. Several shades of either, along with a light or medium green tweed can be

mixed. Shades of tan can be used to create a more fallish effect.

Backgrounds: Before starting to measure for a large background area on a rug, make sure you have enough fabric to complete it. You should be able to cover the area of your background four times with your wool. That is, when you lay your fabric over the background it should be four layers deep to give you enough material. An interesting background usually has more than one shade of colour, even when it is black. Often two or three shades that are very close but not quite the same, can be mixed to create a subtle mottled effect. Mixing a bit of very dark green wool into a black background gives an antique effect. As well, mixing the wool from a camel coloured coat with several other camels or tans makes a warm but light background for a primitive. Backgrounds are often hooked in wavy lines to add visual interest without overpowering the main subject.

Snow: Mix several whites or creams with a light grey or beige tweed to highlight areas.

Dying wools for primitive hooking

I once read that one of the quickest ways to turn a beginner off hooking is to tell them that they need to dye wool. That might have been true for some people but it wasn't true for me. When I began hooking, I thought that I would never need, or want, to dye wool. Before long, I was experimenting with all kinds of dyes. I even threw bits of wool into the cooking water after we had beets or purple cabbage for supper. You don't need to dye wools to hook amazing primitive rugs, but it does give you an edge. Dying wool is also one of my best inspirations. I don't keep records of the amounts of dye I use, and I mix a lot of dyes to create new colours. This is great in that it is free-spirited and creative, but if you want to be able to repeat a colour you must keep a record of the amounts of water, wool and dyes that you use. Great dyebaths can be created from leftover tea, or onion skins for a mottled light taupe. It is a great way of giving an antique look to your mat.

There are a variety of dyes especially designed for dying wool. I have tried other commercial dyes, such as Rit, and have had some satisfactory results. For dying, you will also need a large metal or enamel pot, a set of small measuring spoons, an old cup, a pair of tongs, rubber gloves, and salt or vinegar to act as a mordant. Use newspapers to cover your work surface. Keep some damp rags nearby to quickly clean up any drips as you are working with dyes that can stain. I prefer to use salt as a mordant for primitives because it leaves the wool somewhat duller than vinegar does. Experiment to see what you prefer.

A selection of dyed and overdyed wools.

Dying wools for primitives is a simple process. As the saying goes, if you can boil water, you can dye wool. It is important to read the directions on the dye packages to judge how much dye to use for how much wool. The more dye you use the darker your wool will be. The first step is to soak three 9 x 14 inch (23 x 36 cm) rectangles of wool in water with a teaspoon of liquid detergent so that it will better absorb the dye when it is put in the dye bath. Spread newspaper on your counter top, for easy clean up. Then fill a large, 4 quart (3.5 litres) pot with 3 quarts (2.6 litres) of water and bring it to a boil over high heat. Then dissolve 1/2 teaspoon of dye in one cup of boiling water and add this to the pot on the stove. Mix it well and add your wet pieces of wool, with 1/2 cup of salt. This will create a strong dye bath for a deep colour. Let it simmer for 20 minutes. I often add a piece of wool after the bath has been on the stove for about 8 minutes, and another after it has been on the stove for about 12 minutes. These give you lighter shades of the same colour. When you remove the wool from your dye bath, you must rinse it thoroughly until the rinse water runs clear.

Tips for dying

1. *Crowding the wool into a pot or washer will give a mottled effect to the wool which can be quite attractive when hooked.*

2. *To achieve solid colours, leave lots of room in the dye bath so the wool can move around freely.*

3. *Simmer wools, do not boil them. Boiling may weaken the wool.*

4. *Keep a separate set of utensils for dying. Do not use the utensils that you would use for cooking.*

5. *When used as a mordant, vinegar brightens the wool and salt dulls it.*

6. *Pre-soaking your wool with a teaspoon of liquid detergent helps the wool absorb the dye when you put it in the dye bath.*

7. *Lighter wools take colour better than darker wools.*

8. *Overdying with a bit of black dye will create a dark mottled effect.*

With the leftover dye in the bath, I sometimes add more dye of the same or a different colour, and dye more wool. More salt is also needed. I often will overdye a non-white fabric at this stage—tweeds, tans, peaches—virtually any light colour will overdye well. It is at this point that the real experimentation begins.

Using the washing machine to dye wool

I have had great success with washing machine dying, especially for large quantities of a single colour. It is clean and efficient. The first step is to fill your machine to the minimum level with the hottest water available on your machine. Thoroughly mix one package of dye with two cups of boiling water and pour into washer. Then add the equivalent of 2 1/2 yards (2.3 m) of pre-soaked wool to the washer. Ten minutes later, add 1 1/2 cups of salt. Let this sit for one hour. I sometimes add an extra piece when the wool has been soaking for half an hour to get a lighter shade of the same colour. When the hour is up, put the wool through the rinse cycle of the washer and check to make sure that it runs clear. It usually does, but if it doesn't put it through the rinse cycle again. Remember to read the package for the amounts of dye needed for each pound of wool, and that the more dye you use the darker your wool will be. The washer is great for dying lighter to medium colours. One quick caution is to be sure to throughly rinse the inside of your machine before you put your next load of laundry through. When I am finished dying, I put the washer through a complete cycle with a cup of laundry detergent to be sure it is thoroughly rinsed.

Simmering, bleaching and other methods of dying

I have found that you can tone down really bright colours of wool by simmering the wool in a pot full of water on the stove for 20 minutes to an hour. Older garments from the 1940s and 1950s are particularly good for this because the dyes do not seem to be quite as colour fast as many of

today's dyes are. As you are simmering out the colour of a darker piece of wool, you can add a white piece to the bath to pick up some of the dye that is leaking out. You can experiment with colours to see what happens, or you can add several colours to a bath to "marry" the wools. Use a teaspoon of detergent to loosen the dyes and let the colour run more freely. It can be set using salt or vinegar as a mordant.

Commercial bleaches are another way of removing colour to create a lighter, more neutral shade of wool for dying. I tend to avoid this method because it seems that whenever I touch a bottle of bleach I ruin the clothes I am wearing. For the person who is less sloppy, simply add your presoaked fabric to four parts water and one part bleach, making sure there is lots of room for the fabric to move around freely in the solution. Simmer, not boil, on the stove, and stir until the colour has been removed. Overdying means that no wool ever needs to be thrown away because of its colour. The following chart is a guideline for the colours you can expect to get when overdying wool.

9. *Adding a tiny amount of black dye to any dye bath will darken the colour.*

10. *You can mix dyes to create new colours just as you would mix paints. Blue and yellow make green, red and blue make purple, red and yellow make orange and so on. The overdye chart included in this section can also be used as a guide for mixing dyes.*

Overdying chart

	Over Red	Over Blue	Over Yellow	Over Brown	Over Orange	Over Green	Over Purple
Red	dark red	purple	scarlet	reddish brown	light red	soft brown	reddish purple
Blue	purple	dark blue	green	dark brown	dark grey	blue green	bluish purple
Yellow	scarlet	green	dark yellow	golden brown	yellow-orange	light green	greenish brown
Brown	reddish brown	dark blackish	golden brown	dark brown	dark brown	greenish brown	chocolate brown
Green	dark blackish	blue green	yellow green	olive	myrtle green	dark green	dark green
Orange	light red	dark grey	light orange	rust-brown	dark orange	yellow green	reddish brown
Purple	reddish purple	plum	dark blackish	dark red-brown	dull purple	dark purple	dark purple

Texture

It is the feel of wool that can make a person passionate about hooking. An angora sweater, a cashmere scarf, or the rich intertwined mixture of an old Harris tweed sports jacket, can be the inspiration for a rug. Once, the owner of a small thrift shop in a small village near my home, called me to say she was closing and asked if I would like to come and pick up some materials at a discount. I took her up on the offer, glad to have the opportunity to root through bags and bags of old clothes in search of woolens. I spent the morning going through the mountains of old clothes, pulling out all the wool I could find. Out of approximately 50 pieces of wool, it was one piece that made me truly glad I had come. If all I had left with was that one rust, tan, and green jacket it would have been worth the trip. The thick cloth of the coat was perfect to hook the leaves of Fenwick Hill (near where I live) in the fall. I used this piece of wool every fall for three years, savoring it and sparingly sharing it among the autumn mats that I make each October.

Various wools work to create different effects in mats. Using different textures in a mat, some lightweight, some heavier weight, some tweeds and some plaids can make your rug quite interesting. Some lighter weight wools can be quite thready, when hooked. These threads can be trimmed off for those who prefer a neater look, but sometimes they help to make an ocean look rough, or the grass look more natural. You can also play with texture by cutting you fabrics different widths. I use a wool cutter most of the time, but I hand cut some wool for nearly every rug. The thicker hand cut wool adds depth and strength to the design. It is rougher, and very noticeable in a rug.

Thicker, heavier weight wools, make great backgrounds as they hook up quite quickly. You should experiment with them, as some people find them hard to work with while others favour them. The best way to discover what sort of effect or texture you will get from a type of wool is

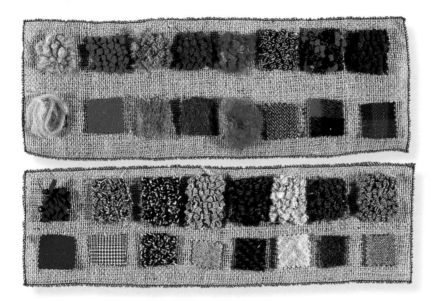

Swatches of wool cloth and samples of what each would look like hooked.

to hook a square inch of it. The chart above, and the one on page 58, show various types of wool as swatches and how they look when hooked.

Generally, primitive rug hooking involves outlining an area and filling it in without worrying about direction, but texture is created in your rug by the way you hook. Wools can be hooked a little higher and clipped or shaved off to create a furry or sculpted look. The direction of your hooking can increase the textural quality of your rug. I sometimes try to hook in a direction that suits the object I am hooking. For example I will often hook a roof in the same diagonal lines that form the line of the roof. The curved back of a cat can be hooked in the motion of the curve to increase the effect.

The art of rug hooking

Designing Rugs

My first rug was a small stamped pattern of scrolls and flowers that came in a kit complete with the wool cloth required. By the time I had finished it, I knew that I would continue hooking but I also knew I wanted to design my own patterns. I had not drawn since I was a young child, but I thought I could manage to draw something. Inspired by a piece of wallpaper, I roughly sketched a chintz pattern onto some burlap and began hooking with the ten or so fabrics I had gathered from thrift stores. The rug, though inspired by the wallpaper, turned out to be nothing like what I had in mind. Even though I liked the rug, it was a disappointment because it was so different from what I had imagined it would be. This first disappointment was a valuable lesson. I learned that primitive rug hooking has a life of its own. Until you are well versed in using a variety of colours and textures of fabrics it will be difficult to create the visions you have in your head. This is important for aspiring beginners to realize.

When you begin designing your own rugs, you enter a new level of rug making. You elevate the world of craft to the world of art. Not everyone will want to cross the threshold, and no one should attempt to unless they feel driven to design their own work. If a person chooses, they can continue to make wonderful hooked mats from stamped patterns. They can express themselves through the use of colour and texture which can be artistically executed. Designing rugs is not for everyone, and many people will design a few rugs, or go back and forth between designing their own and using stamped patterns.

A person usually becomes interested in designing their own rug after they have hooked several patterns. Unless you are particularly talented artistically, and could never see yourself hooking someone else's design, I suggest starting with a stamped pattern. This allows you to focus on learning the technique of hooking, and becoming familiar with the use of

Facing page: "Mr. Bernie,"
14 x 49 inches. My childhood
neighbour, Mr. Bernie, was an
old man who liked to putter.
He was always around and
good to the children. He never
had a horse when I was a
small child, but I was always
told that he used to have one.
Collection of the artist.

"Scrolls," 18 x 30 inches. This
was my first rug. I was taught
by Marion Kennedy at a Nova
Scotia Rug Hooking Guild
meeting. She provided me with
a complete kit, and I finished
it within a week.

colour and texture in making mats. Once you learn the basics you can venture into creating your own design.

Allow your designs to grow and develop; remember that making a rug is a process of trial and error, and that a design may evolve as you work on it; have confidence that your collection of designs will grow and improve over time. In short, although you may be disappointed in your first few attempts at design, you should not give up as long as you feel you have something to express that rug hooking could help you do. I still have my first design rolled up upstairs, along with my first stamped pattern. They are more important to me than some much more beautiful room-sized carpets I have made, because they reflect my growth. If you hate the first few designs you hook, roll them up, put them away and keep at it.

Designing can be about expressing feelings and ideas, recording an important event, or about playing with colours and coming up with a funky, traditional, contemporary, or just really fun mat that looks great on the floor. I still like to vary the types of designs I make. After I have

"Chintz Rug," 28 x 38 inches.
This is the first rug I ever
designed. I wanted to do it as
much like my grandmother did
as I could, so I hooked it on a
burlap bag and drew the
design on myself. It turned out
much different than I had
imagined, but I still find the
border very pleasing.

created a series of rugs that tell stories, I like to focus on playing with simple ideas such as houses, chickens, or leaves to create a series of floor mats. Once I have finished working on large room-sized rugs for a period of time, I find I like to shift to smaller pieces. I enjoy the changes, and I get a great deal of pleasure out of the repetitive thrumming motion of pulling the rags up through the burlap. It would be terrible for people to get so serious about mat hooking that they forget they are just pulling strips of old clothes through burlap, a job that women have done for generations before them as a thankless and unimportant household chore. Don't get too heady about making mats, keep the primitiveness in primitive. If we begin to think that we are too good to make a mat for the front door, we've lost our connection to what it was all about.

It is easier to design a rug if you know where you are going to put it.

This will not only determine the size of your mat, but it will also help to define the colour scheme. An important consideration can be whether you plan to put the mat on the floor or the wall. Some rugs, such as pictorials, can be seen more easily when viewed face on, and therefore are attractive on the wall. Many floral, geometric, and more primitive patterns are better suited to the floor. However, I have often seen old mats that were definitely made for the floor look great on the wall, especially when surrounded by primitive antiques. Though it is a matter of taste, knowing whether your mat is going on the floor or the wall can be an important consideration when designing your pattern.

Adaptations: your early designs

People often start designing rugs by adapting other designs. There are endless sources of ideas for designs: magazines, pictures, paintings, other people's rugs, your childhood experiences, quilt or other craft patterns. These and other ideas can be adapted to create your own design. When you are not copying a design from another mat, the changes that occur in turning the work into a rug will mean a lot of adaptations strictly because it is a different medium. For instance, if you are using a painting, there will be a lot of adaptations because you are using wool rather than paint. Adapting a pattern means that you take the basic idea and copy it free-hand onto your backing, making a rug design. Instead of copying say, a flower basket design exactly, you would change elements of the design, such as the shape of the basket, the placement and types of some of the flowers, and perhaps the border design. You would decide on your own colour scheme. An adaptation is usually significantly different that the original that inspired it. The first rugs I designed were adapted designs, from wallpapers, photographs in magazines, and items I had around the house. It is important to use the piece of art you are adapting as an inspiration, not as a pattern to be copied, because this would be an infringement on the copyright of the original designer.

Templates: An old fashioned way to design

I saw my first set of templates for mat hooking while visiting a 92-year-old year old woman who had hooked mats as a girl. She had saved the scroll-like stencil, made out of plain brown paper, even though she had long given up mat hooking. She explained that it was common for people to have a set of templates that they used to draw their own designs on to a feed bag. This is a good idea for designing, although it is not frequently practiced today. A person can create a set of stencils or templates for oneself so that patterns or elements of patterns can be repeated easily. Some common subjects that people created templates of are Victorian scrolls, leaves, flowers, cats and other animals, houses, etc. Today, templates can be made out of a good stiff cardboard and an Exacto knife. Any materials that are good for making stencils can be used for rug templates.

Expressing yourself in your designs

My real passion for hooking began when I learned that I could really express myself through rug hooking. Several years after I began hooking, I designed and hooked a large mat (3 x 5 feet; .9 m x 1.2 m) which I called "Before Joey." The rug was based on a trip I had taken when I was 15, with my Uncle Donald to Paradise, Placentia Bay, Newfoundland, the outport community where my father had grown up. After sailing across Placentia Bay on the coastal ferry that travels the south coast of Newfoundland, we got on a small skiff that took us into Paradise, a village that had been abandoned in the 1950s with Joey Smallwood's resettlement program. This was a program that moved families from the coastal outports of Newfoundland that could only be reached by boat, to the larger centers that were connected by roads. The whole time I spent in Paradise, even at the age of 15, I could sense the loss that had occurred. Empty homes, churches whose altars were shattered, and abandoned

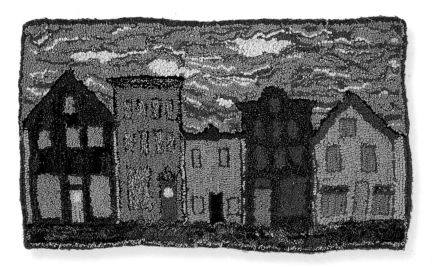

"Downtown Amherst," 22 x 36 inches. This rug was about my third or fourth design. I adapted it from a printmaker's linoleum cutout found in an antique store. At that time I had very few wools to choose from, but the overall blue effect is still very pleasing.

The linoleum cutout found in an antique store, 4 by 7 inches.

wharves and fish houses stood like phantoms of the activity that had once taken place. It was impossible not to imagine the voices of fisherman yelling up from their boats as they approached the shore, or women calling to their neighbors as they hung out the clothes to dry. It was not until years later that I would truly understand the loneliness I felt during that visit. It was through making "Before Joey" that I could express this experience and it was by expressing this experience in mat hooking that I became passionate about hooking mats.

Knowing that mat hooking was a medium for expression gave me a new kind of freedom in design. I could express my own ideas, the ideas of others, my thoughts and feelings about the world around me. Suddenly, I had found an outlet that I did not even know I had been seeking. In this way, rug hooking has been a gift for me; it allows me to tell stories about the things I believe to be important, without ever writing a word.

"Before Joey," 60 x 36 inches. This is the rug that taught me I could express myself through hooking. It depicts how I imagined the community where my father grew up, before resettlement. The rug was based on a visit to the abandoned community when I was 15, and the stories my father told me about growing up there. Collection of the artist.

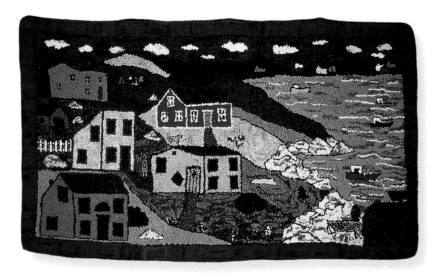

Elements of design

Some of the best tools for designing rugs are things you probably already have. A metre or yard stick, a t-square, a black permanent marker, some cardboard, and your backing are all you'll need to complete the design. If you want to trace some elements of your design off other things you can use a tracing fabric available at fabric stores, or a thin tracing paper from an art supply store. Using the paper or fabric you simply trace the elements of design that you want to use in your design with a black permanent marker. You then transfer it onto your backing by retracing it in the area you want it with the permanent marker; the ink will seep through onto your backing. To design mats you will need to think about colour and texture as previously discussed, as they are crucial if you are working on stamped patterns. Other important aspects are subject, placement of the elements of the design, the use of pattern and repeti-

"A Fish Story," 40 x 40 inches. Portrait of the artist as a child. I remember going to the wharf to buy cod with my father. They were so big that when we brought them home for my mother to clean, the head and tail would spill out of our deep kitchen sink, even though the fish was folded in two. Collection of Joan and Derek Burney.

tion, and perspective. Choosing your subject is the first and most important part of your design. Your early designs should be simple and uncomplicated. The first step in choosing a subject is to equip yourself with a good sketchbook. Buy yourself a nice, hardbound book with a thick quality paper, that looks as if it is too good for you to draw in. Then start drawing in it. As you draw, ideas will emerge. Don't worry about the quality of your drawing. The only thing that will improve it is to continue sketching.

Most of us are timid about our drawing abilities and often we stopped drawing as children. Instead of using other peoples work as something to grow from we allow it to stifle, and intimidate us. When I started rug hooking I had not drawn much for years, but as I continued to practice I

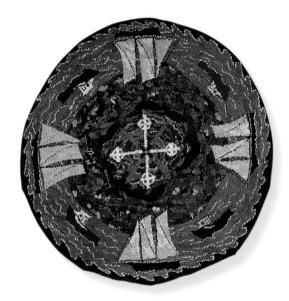

"A Life by Land and by Sea,"
62 inches in diameter.
Schooners, fishing boats and
the greens of the forest
symbolize our Atlantic
Canadian life. Celtic crosses,
net needles and waves, are
reminders of deep traditions.
Collection of the artist.

could see myself getting better. I try to draw something the way I see it rather than the way it actually is. This is important in lending your own flavour to your drawings. Close your eyes and imagine what something looks like. Try to follow the image you have in your mind when you are sketching rather than looking directly at it. When you are looking directly at something and sketching it, it is easy to get frustrated when it is not looking exactly as you think it should. Remember that you are trying to get an impression of something rather than an exact image of it. You are not taking a photograph, but making a mat.

Most of my designs over the years have developed from sketching. I have filled four or five thick books with rough drawings, and I still go back to them for ideas. If you are disciplined, it is a good idea to get in the habit of sketching for ten to fifteen minutes every day, just as if you were keeping a journal. As well as being a good source of ideas, they also become a good record of your progress.

Once you choose a subject that you want to focus on, you can decide what type of design you would like to use (i.e., geometric, pictorial etc.). For example, your family's history of building boats could be reflected in a simple mat with a plain centre and a lovely border of boats. Try to be creative in the execution of your subject, rather than always drawing the idea as a pictorial you can use symbols to create a geometric, or floral design. These ideas can be further worked out in your sketch book before you start to transfer the design onto burlap.

When you are creating the design, make sure that it has some balance and a point of interest. Your point of interest draws the eye and is particularly important for pictorials. It doesn't need to be in the centre of the

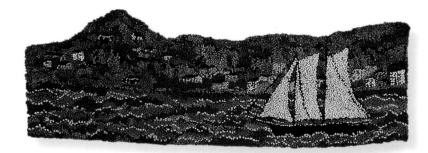

mat, but can be, and often is, at the centre of simpler primitives. Balance in a simple primitive, can be as simple as placing a tree on either side of a house, or sloping a hillside down-wards. Rules of balance, which are crucial in paint-ing, are meant to be broken

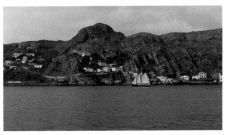

when you are making hooked rugs. They can, however, be used as guidelines when you are trying to achieve a particular effect in your mat. One or several elements of the design can be repeated over and over again, to create an interesting border. I never stop looking for inspiration for my next design, and sometimes it comes at unexpected times and in unlikely ways. Sometimes I drive by the same house day after day, but one day it looks different, perhaps the family has had their winter's wood delivered and they are chopping it up. All of a sudden the house becomes a mat design rather than just part of my daily surroundings. It is also important to look at the colour of your surroundings to record what they really are. Don't assume that the grass is green. Keep your eyes open to the landscape around you—the places you travel, the places that have meaning in your life. What is it about your childhood home that keeps you yearning for it? How did your grand-father look when he held his pipe? What colour were the beach rocks where you grew up? These and a thousand other questions about your life lead you on a healthy process of self-discovery and can really add a lot to your ability to express yourself in your mats. Taking photographs can help you to remember the colours and placement of objects. This can be an important source of inspiration for designing. Rather than trying to

A rug depicting a schooner sailing into the Battery, and the photo that inspired it.

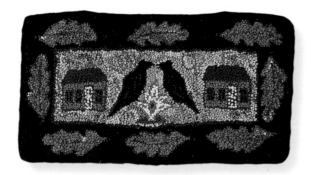

This is an example of creating your own design from the templates reproduced in this book. A single motif can be repeated or several combined to create a variety of entertaining designs.

copy the image on the photograph exactly onto your backing for a mat design, choose three or four things in the picture that make it unique.

Drawing with perspective means that you are drawing from the point of view of the observer. Though somewhat important for pictorials, it is not that important in most primitive mats. A simple rule to use is the closer an object is to you, the larger it should appear in your picture. Many art books provide material on perspective and these can be studied if you are interested in making a realistic image. In making primitive pictorials, perspective should only be as important as you want it to be; you should not let yourself be bound by it. If you need to, get a little help from some one who draws well, and understands perspective. Often artists or designers get help from assistants to help them execute an idea they have in their imagination.

Try to remember that designing is about being free to express yourself, and to be creative. There are no strict rules. Keep your eyes open to ideas, but be careful not to plagiarize. Design is not about making minor changes to someone else's idea and calling it your own, it is about using other people's ideas to develop your own work. Good designs sometimes take time to evolve; let them simmer in your mind, or create a group of rugs on the same theme so that the idea has time to emerge. Most of all, have fun with design, and create rugs that matter to you—rugs that give you pleasure while you are making them, and that you will enjoy as they grow old with you.

"Floating Roses," 62 x 70 inches. Mansard roof houses surrounded by overgrown rose bushes, are separated from the border of wild flowers by a stylized yellow wave. In the centre, primitive roses lie upon a mottled background of dark green and black.

Beginner Projects

What you will need:

- 3/4 metre (2 1/2 ft.) of burlap or preferred backing
- Rug hook
- 2 1/2 metres (8 ft.) of black cotton twill tape
- Rug frame
- 1/2 metre (1 1/2 ft.) of mixed blacks
- 1/8 metre (5 in.) of mixed dark reds and wines
- 1/12 metre (3 in.) of dark green
- 1/4 metre (10 in.) of medium green tweed
- 1/3 metre (1 ft.) of mixed tans

Old Fashioned Roses

I chose this mat as a beginner project, not only because it is easy to do, but as a tribute to my grandmother, Alice Ghanney Hayes, from Conception Bay, Newfoundland. Almost all her mats were floral. My mother says about her, "She'd take a piece of charred wood from the fire and she would draw a few roses and then she'd put a diamond around it. Then sometimes she'd draw a few leaves or scrolls or something in the four corners and that's all she did."

You can draw this mat freehand like my grandmother did or you can use the sketch provided. The sketch can be copied onto an overhead, and projected using an overhead projector onto your backing. You can then copy the projection to draw the design.

1. Draw your pattern on the backing.
2. Attach the backing to your frame
3. Following the instructions described in the preceding section, begin to hook your mat. Start by outlining the centre roses with black. Randomly fill in the roses with the mixed reds and wines. Three different shades of red or wine will work well.
4. Outline leaves with dark green and fill in with medium green.
5. Fill in the background inside the diamond with mixed tans. With the darkest shade of tan, hook wiggly lines and fill in with two or three lighter shades of tans.
6. Outline the larger diamond with one shade of the mixed reds, and fill in with the dark wines and reds.
7. Outline scrolls with dark wine, and fill in with medium green tweed.
8. Fill in the background outside the diamond with mixed blacks hooked randomly.
9. Finish your mats, following the instructions on the preceding pages.

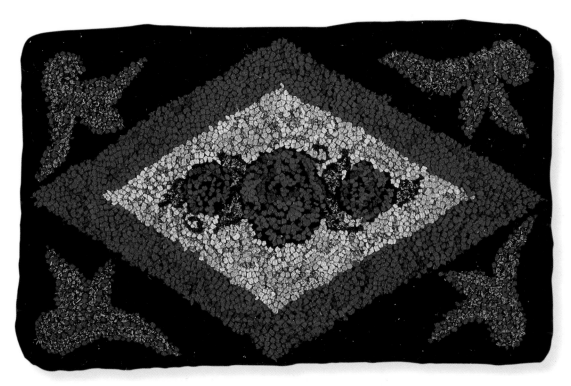

Beginner project
"Roses and Scrolls."

Template project

Templates, as described earlier in this book, are helpful for the beginner or the experienced designer. The drawings on this page are uncomplicated images that can be used as elements of your own design. Together with these and your own ideas and drawings you can begin designing your own patterns.

1. Photocopy and enlarge the drawings you want to use onto a lightweight card stock, available at most stationery stores. You might want to enlarge each drawing to several different sizes so that you will have extra choices for designing.
2. Cut the designs out of the cardboard to create a set of templates or stencils.
3. Play with the stencils, arranging them in different ways on your backing. Once you decide the placement you can trace the stencils using a dark permanent ink marker.
4. Follow the basic hooking instructions to hook and finish your mat.

- *Rug hook*
- *Burlap or preferred rug backing*
- *Rug binding*
- *Wool cloth appropriate for your design*
- *Access to a photocopier*
- *Lightweight card stock for photocopier*
- *Scissors*

Conclusion

Making rugs, whether you choose to design your own or hook stamped patterns, is a meaningful past-time steeped in history and tradition. When you make a mat from bits and pieces of fabric collected from various sources, you are tying the strands of yours and other people's lives together into a bit of culture. Making primitive rugs was a natural offshoot of living along the cold Atlantic waters of the Canadian east coast. I take a great deal of pride in the fact that I continue to make mats in much the same way as my grandmothers did in outport Newfoundland. Since they had both died before I was born, it has created a link to the past for me, making me feel connected to ancestors who would have otherwise been buried in old forgotten stories. As you make your rug, remember that although the tools and materials may now be readily available, and have evolved somewhat over the years, essentially the techniques and processes are the same as they were when the early settlers first started making mats. When you make your rug, you are carrying on a strong tradition, which has been growing and evolving along the Eastern Seaboard for over 150 years. Do it with a respect for the simplicity of the past, but with an open mind to innovation and change so that mat making can continue to thrive along our shores.

Bibliography

Barbeau, Marius, "The Hooked Rug—Its Origin," as in The Transactions of the Royal Society of Canada, Third Series, Section 11, Volume 36, 1942.

Barbeau, Marius, "The Origin of the Hooked Rug," *Antiques Magazine*, August, 1947.

Boyd, Cynthia, "Newfoundland and Labrador," *Piecework Magazine*, Colorado, Interweave Press, January/Febuary, 1998.

Blake Vernon, "The Way to Sketch," New York, Dover Publications, 1981.

Buckler, Ernest, *The Mountain and The Valley*, Toronto, McLelland and Stewart, 1984.

Chiasson, Anselme Father, and Deveau, Annie-Rose, "The History of Cheticamp Rugs and Their Artisans," Yarmouth, Nova Scotia, 1988.

Crouse, Gloria E., *Hooking Rugs: New Materials, New Techniques*, NewTown, Conneticut, The Tauton Press, 1990.

Fitzpatrick, Deanne, "Hooking Traditions Together," *Piecework Magazine*, Colorado, Interweave Press, January/February, 1998.

Fitzpatrick, Deanne, "Hooked on Rugs," *Rug Hooking Magazine*, Harrisburg, Pa., Volume X, Number 3, November/December, 1998.

Fitzpatrick, Deanne, "Rugs as Art," *Rug Hooking Magazine*, Harrisburg, Pa., Volume IX, Number 5, April/May, 1998.

Fitzpatrick, Deanne, et al, *Hooked Mats: One for Sorrow Two for Joy*, Halifax, Art Gallery of Nova Scotia, 1996.

Kent, William Winthrop. *Hooked Rug Design*. Massachusetts: Pond-Ekberg Company, 1949.

Kopp, Joel and Kate, American Hooked and Sewn Rugs: Folk Art Underfoot, Albuquerque, University of New Mexico Press, 1995.

Lawless, Dorothy, *Rug Hooking and Braiding for Pleasure and Profit*, New York, Funk and Wagnalls, 1976.

Leitch, Adelaide, "Pictures on Brin," as in *Canadian Geographical Journal*, Volume LVI, No. 2, February, 1958.

Lynch, Colleen, "The Fabric of Their Lives," St. John's, Newfoundland, Memorial University Art Gallery, 1980.

MacLaughlan, Marjorie, "Landscape Rugs in Quebec," as in *Canadian Geographical Journal*, Volume 1, No. 8, December, 1930.

McLauchlan, Laura, and Young, Joan, "Reading the Rugs of Shelburne County: The Art of Scraps," *University of Toronto Quarterly*, Volume 65, Number 2, Spring, 1996.

Moshimer, Joan, *The Complete Rug Hooker*, Kennebunkport, Maine, Leith Publications, 1986.

Ryan, Nanette, and Wright, Doreen, Garretts and The Bluenose Rugs of Nova Scotia, Halifax, Nova Scotia, 1990.

Ryder, Huia. "Handcrafts in New Brunswick" as in *Arts in New Brunswick*, ed by R. A Tweedie et al. New Brunswick: Brunswick Press, 1967.

Traguair, Ramsay, "Hooked Rugs in Canada," as in *Canadian Geographical Journal*, Vol. XXVI, No. 5, May, 1943.

Turbayne, Jessie, *Hooked Rugs: History and the Continuing Tradition*, Pennsylvania, Schiffer Publishing Company, 1991.